TOO WET TO PLOW

The Family Farm in Transition

Text by
JEANNE SIMONELLI

Photographs by
CHARLES WINTERS

NEW AMSTERDAM
New York

Published in 1990 by
NEW AMSTERDAM BOOKS
171 Madison Avenue
New York, NY 10016

Library of Congress Cataloging-in-Publication Data
Simonelli, Jeanne M.
Too wet to plow: the family farm in transition/text by Jeanne
Simonelli: photographs by Charles Winters.
p. cm.
ISBN 0-941533-64-6
I. Winters, Charles D.,
1941- . II. Title.
HD1476.U6N77 1989
338.1'6—dc20 89-18009

Printed and bound in Hong Kong.

This book is printed on acid-free paper.

Ah, when to the heart of man
 Was it ever less than a treason
To go with the drift of things,
 To yield with a grace to reason,
And bow and accept the end
 Of a love or a season?
 —*Robert Frost*

ACKNOWLEDGMENTS

It was a rainy September afternoon in 1986 when Charles Winters and I set out to document the story of Catskill Mountain dairy farming in a time of great transition. In doing so, we were following the tradition of the photographer Lewis Hine who noted that it is "Ever the Human Document to keep the present and future in touch with the past." We hoped to continue that document by chronicling a portion of the American experience during a period of rapid change, using text and photographs to tell the story. For an anthropologist, working with a photographer was a natural association, since anthropology is in part a visual discipline which can only be enhanced by skillful imagery. Though raised in the city, I had long been fascinated by agriculture, but knew nothing of its subtleties. On the other hand, Charlie had grown up on an Ohio hog farm and could look at a barn and see more than just a building full of cows.

From the moment that we arrived at the first farm, the making of this book involved friendships and associations that we are not likely to forget. The farmers of Delaware and Otsego counties are the faces and stories that make up these pages. During our months of work we visited their farms during the workday, talked with family members about their hopes and expectations, and sometimes attended farm liquidation auctions. As we reviewed the images and interviews that our work was producing we were sometimes discouraged. Viewed separately, many told a gloomy story. Yet when finally taken all together, the montage of people, land, livestock and structures carried with it dignity and underlying joy. It was a celebration of a life that has been the cornerstone of our American heritage.

There is no way to adequately thank all who participated for their cooperation and understanding. Bob and Ruth Avery opened their home and lives to us through a year of difficult choices. Noel Davis provided insight into farm problems, becoming a good friend in the process. We rode on tractors and behind horses with the Rockefellers and the Gielskies. We experienced auctions with the Sherwoods and the Smiths. We met the new Palmer grandson and watched the Davis and Tompkins children grow. Though the others are not thanked here by name, we hope they know that their kindness has always been valued and that they will see themselves portrayed in these pages with the dignity and strength that was evident to us throughout the year of our study.

In addition to moral support, this project could not have proceeded without significant material backing. The initial grant was sponsored by the Newman Foundation of Oneonta, New York, and was funded by the New York State Council on the Arts, through the Upper Catskill Community Council of the Arts. Cooperative Extension of Delaware County sponsored a grant from the New York Council for the Humanities. Additional funding was received from the State University of New York, United University Professions. Technical support was provided by the State University of New York College at Oneonta, especially by the staff of the Instructional Resources Center.

The completion of a creative work is not always a smooth process. Consequently, a debt of gratitude is owed to my family, real and extended. My daughters, Elanor Rimassa and Rachel Nespor, and my friend Annmarie Albertsen gave me the freedom and support needed for writing. Barbara Mathews, Jill Begelman and the folks at the Autumn Café shared thoughts, walks, and innumerable Hot Open Veggies over the months. Special thanks and two bags of concrete go to Erik House, who gave me the "gift of good land" during the writing of this book, as woods, pond, and solitude provided inspiration and images. His eleventh-hour editorial suggestions were also much appreciated.

Photographers, too, have special needs. Darkroom space was provided by Betty Alexander in a peaceful, country setting. Charlie's daughter, Natasha Winters, looked at countless contact sheets and helped select images, continuing her role as critic and life-long friend.

CONTENTS

PHOTOGRAPHS

PREFACE

IT is six A.M. on an autumn morning in Delaware County, New York. Frost coats hay and farm machinery. A sleepy-eyed young girl pours boiling water into the nozzle of a frozen hose so that she can water the sheep before dressing for school. Inside the barn, mother, father, and a hired hand are midway through the first of two daily milkings of 110 Holstein cows. After fastening the milking machine to the swollen udder of one of the shifting black and white bodies, the woman rubs her ungloved hands and pauses to comment.

> I'm thirty-eight years old and already my hands are red and puffy when I wake up. What's it going to be like when I'm sixty-eight? We're getting older and so are our children. In between milking, haying, and cutting corn, we spend a lot of time trying to make sure that the kids get to the sports and social activities that other teens attend. They don't see a future in farming. In spite of myself, sometimes I don't know if I do anymore, either. It's not just economic. It also has to do with what we want out of life, for ourselves and our children.

American farming, like agriculture worldwide, is in a period of crisis. Domestic agricultural policy, which equates efficiency with economic profit, threatens the survival of mid-size farms in all areas of the United States. Caught in a web of government farm policy, world economic conditions, and impersonal political decisions, many farm families have been forced to consider whether they can continue in a business that no longer pays the bills. As one farm woman put it: "I figured it out one day. Together, we were working 120 hours per week. It seemed like we were earning minus five cents per hour. We're making an income of ten years ago in today's economy. That's the crunch faced by the American farmer."

The farm crisis is more than economic. Since the close of World War II, four million farms have ceased operation, altering the way of life in rural communities. This pattern is accelerating, but the social institutions that once helped families and individuals adjust to change no longer exist. As a result, rural communities and farm regions, as well as individuals are affected. They face a future that is likely to bear little resemblance to the way of life that preceded it. This book provides a portrait of that way of life and of the people, livestock, land, and communities which are American farming in this time of transition. This introduction is a factual prologue. It gives a broad outline of the historical antecedents of American agriculture today, raises issues of land and economic policy, and supplies background information concerning the area depicted in the photographs and text. In contrast, the book's four chapters are an impressionistic composite of the daily life of more than thirty families and individuals. Like the rhythm of farm life, the images and prose are arranged by season. They give the reader a sense of the joys and struggles of farming over a one year period.

THE FARM DILEMMA

From the time of the nation's beginnings, a basic issue in American farm policy has been the question of farm size and organization. Alexander Hamilton supported the sale of national land to whomever could afford to buy it, though the eventual result might be huge manorial estates. In contrast, Thomas Jefferson believed that "those who labor in the earth are the chosen people of God, if ever He had a chosen people . . . ," and these could only exist if land were made available in limited amounts to small, independent farmers. An 1820 law authorizing the sale of land in 320 and 160 acre parcels allowed Jefferson's view to dominate. The distribution of farmland to individual homesteaders was supported by additional laws passed during the nineteenth century. From the time of the Civil War to the beginning of the twentieth century, farm output rose continuously. Between the years 1910 and 1914 American agriculture experienced its golden age, and

high, stable prices prevailed through World War I. By 1921, however, the most disastrous farm slump in agricultural history had begun. Government response included production controls aimed at raising prices and stimulating diversity in the kinds of crops grown. Benefit payments were offered to those who limited the acreage of staple crops (Blanpied 1984). During this period the farm population dropped. In order to survive, those who were able to do so intensified their operations, investing in tractors, combines, and sophisticated production techniques. But they increased their debt load in the process and faced the problem of finding new markets for their goods (Howe 1986). Those who survived this first reduction in the number of American farms reaped the benefit of a rising demand for farm goods during World War II, as well as a change in farm policy that favored the production of surpluses. This "free market" approach was designed to force the less efficient farmer out of business.[1] As a result, rural poverty increased during the 1950s and

[1]Opponents of the policy pointed out that the ultimate outcome would be the ruin of hundreds of thousands of farm families, and the possible end of traditional social values which were closely associated with American farm life. This group supported a carefully managed price structure which would guarantee farmers a sustaining income, as well as production controls to limit surpluses. The resulting farm policy during the period following the Korean War consisted of price supports, "surplus disposal" programs, and production controls. The program proved unsuccessful, farm income fell, and the exodus of small farmers continued. On the remaining farms those who could afford to utilize technological advances were able to increase production, and surpluses rose. The threat of a farm-initiated depression during the 1960s forced the government to introduce another system of production controls and income aids. Those in opposition argued that the program allowed small, "inefficient" farmers to remain in operation and restricted the ability of others to expand to a size that might prove profitable; they still favored market solutions to the farm dilemma. In 1973 the old price support programs were replaced with a target price program keyed to the rise and fall of market prices. The immediate result was an increase in production, but accompanying high inflation and increased costs of machinery, feed, and fertilizer kept farm income increases to a minimum. As in previous years, the final outcome was fewer farms and larger operations.

PREFACE

1960s. As farm communities began to disin-
tegrate during the 1970s, the Agriculture De-
partment warned of the social consequences
of farm liquidation. By 1980 farm policy had
moved significantly away from depression-era
programs of price supports and strict produc-
tion controls. Farm production costs and in-
terest on short-term commerical loans were
rising radically. In spite of this, many farmers
saw expansion as the only way to stay in
operation and increased their debt load in
order to afford the new equipment needed for
growth. It became almost impossible for the
typical farm family to survive on farm income
alone. Off-farm jobs became a source of cash
for both living expenses and interest pay-
ments on outstanding loans.

THE FARM CRISIS CLOSE UP

On a brisk fall afternoon in Delaware
County, New York, 130 freshly scrubbed
cows are stanchioned in a farmer's barn,
wearing catalog numbers on their bony
rumps. Outside, the mobile loudspeaker
truck of a farm-auction service meanders
through rows of machinery. The past two
years have not been kind to the Catskill
Mountain dairy industry. The auctioneer's
call has become a familiar sound on the back
roads of the county. For the family going out
of business, the day's auction represents the
culmination of months of decision-making
and financial maneuvering. Everyone in-
volved understands that tomorrow will be the

first morning in fifteen years that this farm
won't be milking.

Delaware County in upstate New York
covers 1,466 square miles. At its southeastern
edge, it is located approximately 124 miles
from New York City. The county is made up
of narrow winding valleys, where steep pas-
ture grades quickly into rugged, hilly wood-
land. It has been a dairy farming region for
the past 150 years, with crop production se-
verely limited by the rocky soil and the chilly
temperatures that prevail at the higher eleva-
tions throughout much of the year. In-
creasingly, the area's rural beauty draws fish-
ermen, hunters, and those seeking outdoor
respite from the urban sprawl that moves
steadily closer.

During the mid-eighties, the farm crisis
edged slowly eastwards into the Northeast as
a depressed economy collided head-on with
federal programs designed to restructure the
dairy industry. Under present U.S. policy,
dairy products which farmers cannot sell
elsewhere are purchased by the government
at a set price. The resulting price support
system is a federal program which is admin-
istered regionally.[2] In recent years, the federal
government has attempted to reduce what is
classed as excess milk production. The mea-
sures taken included a rebate program in
1983, a diversion program during 1984–85,
and finally, in 1986, the whole herd buyout
program. The intent of the buyout was to
decrease the presumed milk surplus and
create higher prices for the remaining farm-

[2]Milk processors pay farmers a "blend price" which combines a country-wide price with one established
in regional zones or "milk orders." The former, known as the Minnesota-Wisconsin price, is based on the
amount of bulk cheese sold to the government. The latter relates to the price paid to farmers for their
fluid milk production within the forty-three federal "milk orders." Until 1980, the program succeeded
without causing huge surpluses of milk. However, since 1980 the cost of the program and the size of the

ers. Participating farmers agreed to dispose of their cows and not produce milk for the next five years. A bidding process was used to determine what the farmers would receive for their herds (Milk Industry Foundation, 1987). There was immediate response to the buyout among the 500 active Delaware County farms facing an uncertain future. Eighty-four farmers submitted bids; thirty-nine of these were accepted. In all, 7.8 percent of all County farmers agreed to cease dairy farming, a figure exceeding that found in any other Catskill Mountain county and many of the surrounding dairy states.

If the buyout program directly affected participating families, it also affected those who stayed in dairy farming. Forty percent of the $1.8 billion cost of the buyout was financed by the dairy farmers who continued to milk their cows. During the spring and summer of 1987, fifty-two cents per hundred pounds of milk sold was deducted from the price paid to farmers. For many families, the cumulative effect of this reduction was to take away the $500.00 to $1,000.00 a month which had been used for living expenses.

Under the impact of reduced milk checks and the continuing unfavorable economic climate for small farmers, a steady progression of non-buyout farm liquidations began to occur in Delaware County. For every farm that folded during the buyout, two more ceased

operations voluntarily, if that is the right word. Community social agencies recognized that farm families faced both economic and emotional stress. Formal and informal groups were created in the county to provide residents with a support system, help farm families weather difficult economic pressures, enable them to stay in farming if feasible, or make a successful transition to a new life. They attempted to fill a neglected need of farm families to talk with others who cared, understood, and wanted to keep up the help-each-other rural tradition (Farm Journal 1986).

OFF THE FARM: THE CHANGING FACE OF FARM REGIONS

I don't see any explicit plot to get the land back for suburban development. Sure, if you look around you, there are certain people who seem to be buying up land as fast as the farmers sell it. But it's just the natural flow of things—there's nothing to stop it. Land reform is short term. Economics is the driving factor in what's going on around here.

The farmer was commenting on the rapid turnover in farm land occurring in Delaware County. Advertisements in New York City and suburban newspapers for subdivided land in Delaware County currently outnumber those for all other Catskill Mountain coun-

surplus (as calculated according to Federal guidelines that define as surplus all milk used by the Armed Forces or consumed in school-milk programs) has grown steadily. Pressure to reduce the cost to the taxpayer resulted in a series of programs which offered incentives to dairymen to cut production and incorporated a stepwise decrease in price supports since 1983. As long as government price-support purchases of non-fluid milk products exceed five billion pounds milk equivalent, a fifty cent per hundred weight of milk price reduction can be invoked, as occurred on January 1, 1988. Concurrent with the 1983 changes, federal poverty programs began to give away the stored cheese, butter, and powdered milk which had accumulated as a result of the price support purchases.

ties. Because most of the region lies only three hours from the City's limits, it has become a new frontier and a prime choice of families and individuals looking for weekend and vacation homes. An increasing number of farms pass into developers' hands each year. A classic story is that of one 180-acre farm which went out of production through the buyout. Sold to a development company, the land was made available for viewing on a clear, pleasant July weekend. Carloads of prospective buyers arrived to look at the ten-acre parcels, which included a lovely view of surrounding valleys. Given a promise of eventual electricity, access, and water, the land was sold within two days. Three weeks later, bulldozers and heavy equipment from the Power Authority of the State of New York (PASNY), working on a new heavy duty power line, arrived to cut a swath the size of a four lane highway through the previously unspoiled view.

The sale of untenable dairy farms and the eventual subdivision of Catskill land is a relentless movement which will have to be dealt with in the coming years. According to the county planning board, absentee ownership increased 48 percent during the last decade. Some of the subdivided plots are being sold with improvements already in place, including vacation cabins and shallow ponds for each lot. Planning boards are split concerning how much regulation of development should take place. Many of their members are farmers who see the eventual sale of their own land as a real possibility. They are just beginning to address such issues as the adequacy of septic systems, area water tables, and town budgets which must maintain newly cut roads.

There are less obvious changes that can result from farm sale and subdivision. Farmers often contract to take the hay from large parcels of land. The arrangement has kept the face of Delaware County rural as the seasonal haying prevented the gradual encroachment of weeds and woods upon untended land. When land is divided and sold as unimproved lots, it becomes difficult for farmers to negotiate with forty separate individual absentee owners. The result is both a gradual succession of field into woodlot, and a farmer who will be forced to purchase hay in order to maintain the herd through the winter. For many, this added burden signals the beginning of the end, as it signals change in the county landscape.

Will Delaware County cease to be a farm region and become a winter-summer vacation land? Not entirely. The reality is that there is a need for milk production in this area and in the nation. As a result of federal food policy there is now no stored surplus of non-fluid milk. Moreover, the giveaway, designed not as a legitimate social program but to rid the nation of a supposed surplus, has become a social necessity. On a national level, the federal government may find that it must continue to encourage and purchase milk supplies that it now classifies as surplus, although they are regularly consumed by school children and in the armed forces. On the local level, the need for fluid milk remains stable, though demand for milk to be used in the non-fluid manufacturing sector has gone up. In the Catskills, rival firms, many from outside the state, began to offer bonuses to farmers in order to ensure an adequate supply of milk for commercial production. Recently, New York State enacted a reform of its own milk licensing laws in order to increase competition throughout the marketplace. Unfortunately, the cost of producing milk in Delaware County is higher than in many

other parts of the country, because of land and market constraints. When the price is high commercial manufacturers go elsewhere to buy, forcing the area to become a fluid market producer, which places significant economic limits on farmers. The loss of the manufacturing sector means the loss of revenue and jobs throughout local communities.

IS THE FAMILY FARM WORTH SAVING?

In 1955, Delaware County ranked tenth in the nation in the amount of milk produced at its more than two thousand dairy farms. By January 1985, the number of dairies dropped to 535, though milk production reached record levels. By July 1987, the number of farms declined to an estimated low of 395. In spite of the decrease in the number of farms, the size of remaining farms continues to increase.

Domestic farm policy today favors the large farm, at the expense of the mid-size operation. Economists and social scientists alike have begun to debate the question of whether the family farm should be saved. Calling family farms a "costly and inefficient production unit," one observer suggested that "it does not appear that these enterprises are better land stewards (than are large farms) and there is little evidence that an evolution

toward fewer, larger farms would destroy rural communities" (Peterson, Dickson and Bowker 1987).

Driving down certain roads in rural Delaware County, the opposite conclusion would be bound to suggest itself. Empty, hollow-eyed buildings line a Main Street cloaked in mid-day quiet. Piled in the window of the rarely open second-hand store are attic and kitchen remnants, no longer needed. A few farmers gather in the diner, drinking coffee, eating fries, talking slowly. Their sentences are drawn out, perhaps to postpone the impending silence of tomorrow. In one small hamlet, the local Agway, a feed and seed store, closed its doors in early March, its services no longer needed in an area of declining farms. As with most closings of farm-related services, the toll was not just a lost business, but the lost jobs which provide off-farm work for those in the local community.[3]

Those examining the impact of farm liquidation in Delaware County are quick to point out that there are still prosperous farmers in the area. Their success is attributed to "good management" and to the fact that they are "land rich" and have a land base to borrow against. On the large scale, it is unclear at present whether the sale of cows at auction has actually reduced milk production in the area, or if these cows are simply being returned to production at the remaining farms

[3]A recent study in a dairying area of Minnesota similar to that of Delaware County examined the impact of the farm crisis on its five hundred farm region. It was estimated that in one year:
- fifty families would leave farming
- forty families would be forced to look outside the area for jobs
- three farm dealership employees would also be out of work as farm equipment sales fell
- $421,000 less would be spent locally on food, clothing, and other items, causing more layoffs
- overall revenue loss to the area would be close to $6,576,000, including about thirty non-farm jobs

Impact of Fewer Farms on Rural Communities. New Berlin Gazette, New Berlin, New York, Mar. 4, 1987.

in the county. This is the critical issue for economists who are only concerned with determining if the overall milk shed is threatened by a decrease in the level of production.

LANDHOLDING: WHO GETS TO HOLD IT?

On a quiet road that flows upward behind the region's largest city, a solitary silo peeks through trees just beginning to bud out. A second growth of beech and birch have reclaimed pasture where coyotes can sometimes be heard calling plaintively at midnight. Over the hill and through an unoccupied grove, fields lie turned and waiting for the final frost to pass. The winter feed, stored in vinyl bags which look like huge white worms, sends a heavy musk of fermenting hay through the damp air. The snows have gone from the soft ridges of the nearby mountains, revealing the next season and cycle for Catskill farmers.

During 1987, boom-year prices and lowered feed costs contributed to the impression that the worst of the farm crisis might be over for the nation. Farmers' overall debt dropped, as they chose to pay off loans and make a conscious effort not to engage in renewed borrowing. For New York dairy farmers, however, the future still remains bleak. Their future and the future of dairying is entwined in a frustrating morass of rules, regulations, government price supports and distributor licensing requirements. Agricultural assistance programs, reflecting federal policy, are blind to the needs and concerns of the low-end farmer, the group which comprises all but a handful of Delaware County dairies.

According to a recent study of Delaware County farming, "the most significant challenge in coming years will be to maintain a supportive atmosphere for continued farming in the face of increasing development pressure and population growth" (Fredericks 1986). While there is no explicit federal or state policy designed to recapture Delaware County land for development purposes, it is clear that development pressure and farm failure are interrelated. Though New York has declared its commitment to support dairying as a dominating force in its agricultural economy, a main focus of the state's program will be to stimulate farmers to increase production using methods difficult for most mid-size farms to adopt. These include the application of new biotechnologies, investment in cost-reducing technology, and the consolidation of operating facilities. For the Delaware County farmer facing economic difficulties, it has become a choice between investing in growth and technological change or accepting an offer from a land developer seeking to buy farm acreage. Consequently, explicitly stated federal and state policy that seeks to maintain only the "efficient" or profit-making farm enterprise becomes an implicit program of land redistribution. Given the realities of land and topography in the Catskill region, the state's goal of consolidation of operating facilities can never be met.

Spring is traditionally a time of renewal and new beginnings. Around the Catskills, farmers can be found out in the warm afternoon sun preparing the newly thawed earth for planting. In the barn, women, with children close by, return from in-town jobs to complete their afternoon chores. For Delaware County, as in the past few years, snow melt signals the beginning of auction sales which will further reduce the county's farm population. The asking price of land for development has doubled since 1986, and for

many has become a prime factor in the decision to leave farming. Each individual decision to sell or hold land will contribute to change in farm communities and rural land use over the next decades. Those making economically-motivated farm policy from the distance of legislative bodies either cannot or choose not to see these effects.

REFERENCES CITED

Blanpied, N.A., *Farm Policy: The Politics of Soil, Surpluses, and Subsidies,* Washington, D.C.: Congressional Quarterly, Inc., 1984.

Farm Journal, *Support Groups Rekindle a Flickering Flame,* pp. 40–42. December; 1986.

Fredericks, C.E., *Dairy Farm Variability in New York and Wisconsin: A Two County Comparative Analysis.* M.A. Thesis, University of Wisconsin-Madison; 1986.

Howe, C., *Farmer's Movements and the Changing Structure of Agriculture.* In Studies in the Transformation of U.S. Agriculture. Ed by A.E. Havens. Boulder: Westview Press; 1986.

Milk Industry Foundation, *Milk Facts* (July) Washington D.C.; 1987.

Peterson, E.W., Dickson, D.B., and J.M. Bowker, *Is the Family Farm Worth Saving?* Paper presented at the annual meeting of the Society for Applied Anthropology, Riverside, CA; April, 1987.

Prologue

IT was a magnificent day, seasonable for December. The sun was beginning to melt the snowpack on the farm roads of Delaware County in the Catskill Mountains. I'd stopped, intrigued by a tea kettle and decaying arm chair still sitting on the front porch of an abandoned farm house. A hobo cat peeked its bearded black and white face from behind a once beautiful lace curtain. He'd taken up residence in the house, and I startled him as I skied across the deep snow to examine the sagging, two story building more closely. Inside, the remains of a ten-year-old meal lay scattered on the kitchen table. Vintage bottles, still-packed steamer trunks, and wicker furniture filled the rooms and out-buildings. A magazine tucked forgetfully between barely blue cushions hinted at gentle summer evenings when it was easy to drift and doze in the fading light. A can of Chase and Sanborn on the kitchen counter tricked me into imagining that there was coffee brewing and that I had been expected. It was as though the house stood waiting for someone to pause, to capture its image permanently before it heaved a sigh and finally collapsed into the snow that had fallen silently the night before. In a few years, the land would reclaim the space where the house once stood. Only the lilacs and apple trees would remain to pay tribute to dreams that had been warmed by the fire so many Decembers before.

In the distance, the three silos of an active dairy farm were nestled against one of the quiet hills which are a hallmark of this county's terrain. The valley was crisscrossed by fences of weathered native stone, fields of snow ending in iced and rounded edges at the banks of a rushing creek. Red barn, white house, smoking rising from the chimney: it presented an idyllic picture. It was hard to imagine the area as anything but the dairy farm region it had been for more than a hundred years. Beyond the field, a single doe bounded dog-like through the untouched snow. She was searching for food near small, tract houses which replaced the woods that once surrounded both the working farm and its abandoned neighbor.

Delaware County is changing. The winter sheds a deceptive aura of peace and tranquility over the farm valleys. It is as though the entire county is like an abandoned house, waiting, but only just, for its image to be captured before making a puzzled transition from present to history.

Winter

WINTER came early this year. Though upstate New York is an area where the turn of seasons is a transformation, distinct and unmistakable, the actual change always seems to take people by surprise. They are blasé about the magic, perhaps so that they can trick themselves into being surprised and delighted each time it happens, or, as the days become shorter, postpone the inevitability of the first snows.

Twelve inches of snow transfigured the ground, the mountains, and the roads on November 19th. It was a Wednesday morning and I was due to visit a farm twenty miles across the county at 7:00. The thought of driving merged with too much coffee and created a pothole in my stomach deeper than those found on a country road after snow melt. It had been a heavy storm; a gift to children on a school morning, but the sun was out and the sky was blue. Finally I took off two hours late down plowed roads coated with sand and salt.

On the other side of the mountain, which separates the area's only "city" from its largely rural surroundings, I stopped to pick up the winter-seasoned photographer who was to tell the county's story with me. He was a Midwestern farm boy who brought that experience with him when he came to Delaware County as a photographer twenty-one years ago. Driving with him, I knew that each time we reached the crest of a hill he met old friends: trails once skied; maple trees once tapped; apples gathered from an ancient branch laden and waiting for a child's laughter. He saw the land and people through different eyes than I, a newcomer delighted with its steady beauty. For him, friends of long acquaintance were changing and it was evident in the subtle progression of weed and woodlot into what had once been hayfield or pasture. Today though, in the stillness of a storm morning, we both marveled at whitened branches dipping toward the sparkling ground and towns "sleeping in" as we headed cross-country along near-empty roads.

The electricity went off at about 4:30 A.M. I came to the barn to milk as usual, but everything was dark. It should have been a hint. Went up to the house, but Dan was still asleep. No alarm clock. The cows were getting restless. We tried the back-up generator that we'd bought at an auction sale during the summer, but the wiring needed fixing. We

were gonna have it done before the winter, but really, who expected this much snow this soon? By the time the electricity came back on three hours later I had eighty-five cows bellowing.

The Crawford farm is located about two miles down a road by the same name, a sign of the length of time it has been in operation. In fact, it was started in the late 1890s, with horses and horse drawn machinery, and saw gradual changes through the next century. Like many Delaware County farms, they'd continued to use horses until about ten years ago, and still kept a few to use in logging the woodlot on the steep hills overlooking the farm. At 9:00 that morning, they'd just finished a delayed milking, and in the barn tempers were a little short. The milk truck from Dellwood creamery had arrived to pick up the milk from the bulk tank, as it did every other day. The job finished, the driver began to back out, but the truck got stuck in the deep snow, spinning the massive wheels under its long silver body. Dan sat in the John Deere caterpillar shifting gears with thickly gloved hands. His red and white hat was pulled low over a cold and rosy nose. The Dellwood man, in knitted cap and plaid wool shirt, readjusted the cables, which were already iced over from dragging on the ground. It was a workday, but it was a snow day, slightly different from the regular routine, and nobody really hurried.

Sue Crawford met us at the side door of the two-story white farm house. She had a cap of short, dark curls, round face, and tinted glasses. She was gracious in inviting us in, but there was some skepticism in her voice. "I thought anthropologists studied frogs, or at least native tribes off in Australia," she told us. The well-seasoned farmhouse smelled of wood fire and recently fried bacon. In the living room we warmed frigid fingers in front of an old potbelly with silver trim. Her husband Frank, retired now from active farming, was in the kitchen making sauerkraut. He was using a wooden grater to shred huge heads of cabbage into a large ceramic crock. Though he carefully and almost cheerfully explained the fermenting process, his stern and decisive "no pictures" hinted at a farm run tightly with his family throughout the past 43 years.

The kitchen was a delightful clutter. The long table had seen decades of meals for a family of six and hired hands now just memories. It was covered with the makings of both breakfast and lunch: white bread, mayonnaise, ketchup, chocolate syrup, cole slaw, apple pie, and bacon. Casting her eye along the length of the table, Sue sighed. "Everybody eats at different times. That's why I still use the wood stove. I can just cook it and put it in the warming oven till each one's ready." She pointed to the old

cast iron stove which warmed the recently modernized kitchen. The room was bigger than most city living rooms, a central gathering place for those involved in the continual activity of the farm day.

It was five years since Sue last worked in the barn. She fell down from the hay mow and was hurt, putting an end to the outside work she'd done during forty-three years of marriage. They started the farm with fourteen cows, hauling the milk in metal cans. Frank worked a milk route to earn additional money. Like her son and daughter today, Sue began in the barn at 4:30 each morning. She was married for twelve years before the kids were born and during that time she helped with the summer haying and cut corn in the early fall. Then, as now, farm women took the kids to the barn while they worked. As they grew up they all helped out. For Sue's four, this had mixed results. Once grown, two wanted nothing more to do with the farm; the remaining son and daughter now ran it as lessee and hired hand, respectively. They were outside now finishing work in the biting mid-morning air. Dan cleared the area in front of the barn with the snow plow so that his dad could load some young stock to take to market. Christie, at twenty-three, filled one last wheel barrow with sawdust from the loft, and took it down to the Holsteins stanchioned in the barn. "She can do anything he can do," her mom said. "If you ask her, she'll tell you she can do it better."

Christie was bundled against the cold, but moved swiftly through her remaining chores. Her long hair was piled on top of her head, and she was strong and attractive though dressed in rubber barn boots caked with snow and manure. For her, it was just a job, better than waiting tables. Her brother was her boss and she joked that she could lose her temper in this job without getting fired. She cared for the young stock as well, living with her husband at another farm just down the road. Over the years she'd grown up, left the farm and returned, her life a cycle of ups and downs which resembled the farm's sequence of fortune and misfortune. Like many others, this farm had survived burning barns, sick cows, and the life cycle of its owners. With each difficulty, the Crawfords pulled back, analyzed the situation carefully and changed the operation slightly. This winter's early snow brought with it yet another crisis and retrenchment. It was uncertain whether this would be an active farm when the warmth of spring returned.

We sold a horse yesterday. She was half-sister to that black one over there. Sold it to a man who'd bought one of ours a few years back—never been in harness. But he'd harnessed it up the same day and the horse never gave him a lick of trouble. We got $1200.00 for this one, and that'll keep us going for awhile longer. Hope he has as good

luck with her as he did with the other. C'mon, son. Get that tail out from beneath the harness—that's it. You'll be a man before your mother is.

The first week of January brought eleven inches of new snow; a grey sky pressing low over the surrounding hills threatened more for tomorrow. Steve was optimistic. "It's been a gentle winter so far." The temperature had not yet dipped below zero, and the machinery was not frozen in the morning. It was still possible to spread manure on a hillside every day. A mid-afternoon lull settled over the farm, as Steve and his wife Kathy paused for coffee and conversation. Their oldest son, home from college for his first winter break, dozed in an upstairs bedroom. He couldn't wait to return to school, where he could sleep till eight in the morning. The school bus would soon return with the youngest. He had turned nine that day. A just-baked chocolate cake awaited his return. The kitchen was lined with ribbons he had won at fairs and horse shows the previous summer. A teenage daughter rode the late bus, letting volleyball practice end a day which began in the barn over twelve hours before.

Kathy rose slowly from her seat at the kitchen table and headed toward her work space at the other end of the house. She was a beautician who worked part time in town and part time out of a paneled shop that had once been the family's T.V. room. She did little in the way of farm chores, leaving these to her mother-in-law, who at 82 organized the barn and its activities like a master chef in the kitchen. Kathy's work brought in a steady flow of cash to supplement the family's milk checks, paying for both monthly bills and the little extras that made life fuller for the children. Today's customer was a woman from a nearby farm. As shorn curls piled on the linoleum floor, the conversation centered on the heavy snowfall due to start at sunset.

Outside the house was an aged, but sturdy barn that time remembered painted red. It held eight huge work horses now, a living museum packed with the equipment that had been needed to run the farm in the years before mechanization. A line of horse shoes hung from the rafters, rusted and draped with cobwebs that had not been disturbed in fifty years. The chill air of January laid a crystalline icing on the delicate webs. They glistened unexpectedly as bright sunlight angled in through cracks and windows in the darkened barn. Chickens scurried along the beams above the horses' swaying heads. They seemed not to mind sharing the space with their feathered companions.

It was the nine-year-old's job to water the animals, preparing them for work. It was bitterly cold in the horse barn. There were not enough of them for the body warmth to keep the area at around 52°, as was the case where the cows were kept. Though a

layer of sheep skins was used to protect the faucet from freezing, it still took a kettle of hot water to thaw it enough to fill the battered, old style wash tub that served as a trough. One by one, the horses came to drink, tossing long, shaggy manes and tails with an impatient neigh. Finally, Jack and Jill, the principal work team, finished a lengthy drink and were brought out separately to be placed in the heavy and intricate leather harnesses. Though they were neither Belgians nor Clydesdales, when they worked together it was with precision, straining against the harness, controlled power becoming forceful forward motion.

By Sunday morning, winter's gentleness blossomed into the worst snowfall in twenty-five years. Nineteen inches fell with steady determination. Temperatures dropped to sub-zero levels. The tractor used to pull the manure spreader refused to start and it was clear that the horses would have to pull the spreader, a long gear-driven wagon with back wheels just large enough to make it through the more than four feet of snow.

The horses were hitched to the wagon in front of the barn. Expectant, tolerant, they waited for their youthful driver to flick the reins or give some other signal. With an apprehensive "hup!" the nine-year-old began to drive them slowly. Their heavy breath lay floating on icy, sun drenched air. As they picked up speed, each hoof struck down and forward, sending clumps of snow flying. There was work to be done; they knew it, and were ready to get on with it: legs angled, heads raised, manes flowing, in strength and dignity. Maybe the gears on the wagon would fail, but Jack and Jill would keep on going through drifted fields of wind blown snow.

In the weeks to come the horses would be called upon to perform other winter tasks. As in the Catskills of the nineteenth century, they would be taken to nearby farms to join the neighbor's horses in a log pull, bringing newly felled timber from high on the hillside. Then, while temperatures hovered near freezing and flurries fell sporadically from a somber Sunday sky, the usually silent woods would echo with the sounds of magnificent toil: sweat running under harness decorated with jingling bells, chain link hitting against chain link, children running to escape the furor of massive hooves crashing in determined effort.

The full moon shown on a party of townspeople as they knocked on the barn door at 10:00 P.M. asking to skate on the small, frozen pond nearby. For the farmer, checking his Jerseys one last time, it was close to bedtime, but other people's lives have a different rhythm than his. For those who work in city jobs, the falling temperature means a pond that is safe for skating. For the farmer and farm family it means securing the machinery against the frigid winter wind. Down the road, people are up at

midnight sharing wine with friends on a weekend. On the farm, if the husband is up, it is to run the diesels on nights when the oil can't be kept warm electrically; if the wife is stirring, it is to help a calf be born as darkness reaches toward morning sun.

At 6:00 A.M. sleepy-eyed children join their parents in the well-kept barn. Small hands redden in the dawn chill, as rising light reflects on frost encased corn left standing in one corner of the field. By the time the school bus comes at seven the calves will be fed and the morning milking will be over. When the bus returns at four that afternoon, the cycle will begin again. The cows form a black and white army, stanchioned indoors for the winter months. They eat the hay and silage stored during autumn, filling the gutters of the barn floor with their droppings. Once a day the manure will be spread on the fields, forming dark bands on the crusted snow. Corn sweet, it attracts a flock of wild turkeys. As a green and yellow tractor moves into view, they scatter in an orderly fashion. Running, the turkeys stumble. One leg disappears briefly into the still deep snow, but the line is never broken. On the tractor, the farmer moves back and forth creating rows with the same precision. It is time to think of melting snow, fields to be plowed, and seed prices for the coming spring. It's been a gentle winter so far.

Spring

NIGHT time. Spring time. Frogs are calling in cacophony, newly emerged from below ice that has only recently melted. The full moon shines down on midnight scenes. A blond dog, angular shepherd-shaped, runs silently at the side of the road. Winter's doe, also sensing the final days of frost, dances with her herd in fields bathed in moon rays, their eyes glowing amber. They care little for passing cars, and pause only long enough to sense danger. Finding none, they continue to play, their dance ending with the dawn.

Light shines in sleeping barns. Silos sit isolated against a brightened night sky. Inside, the cows are peaceful. Tomorrow they will be freed from winter stanchions to graze on meadows growing faster than expected. The night stars are dimmed by flooding moonlight. Even a recently-built prefab home has a softened beauty.

Day time. Spring time. The warm sweet smell of milk around the bulk tank suggests a baby's room. It is a seasonable Monday. Some of the "girls," the morning milking over, have been let out to stretch their legs and toss their heads. The hired woman, tall and broad, wearing jeans, a tee shirt, rubber barn boots, cleans the spaces around the empty stanchions and hauls sawdust in a wheelbarrow to spread on Holstein beds. Brushhollow Farm is like its neighbors. Located on a stretch of land wider and flatter than most county terrain, it is a well-kept family farm where generations of work means that the mortgage is paid and that there is occasionally time to think of more than planting and milking. For Marie and Craig Bisbee, recreation lies in the magnificent Belgian horses that they raise and show in competition. In a small enclosed pasture near the red and gray cow barn, two harvest-golden mares hover protectively between the fence and some hidden treasure. Their huge, rippling bodies shelter foals that are less than a week old. Their usually groomed white-blond manes are in disarray. As with all new mothers, there is an air of caution in every movement.

For Marie, there are always foals to deliver in early spring. Both the mares and their offspring trust her, for she is usually present at the moment of birth and her scent is part of the new world that greets them. Standing almost as tall as she, the foals wobble on legs far too long for their bodies.

Between milking and fieldwork, Craig and Marie hitch two three-year-old Belgians to an old but sturdy plow and lead them to an uphill field that will soon be planted with corn. They are preparing for an annual draft horse meet where husband and wife will face off good-naturedly in plowing competitions. Today, in practice, the horses make straight but shallow furrows, since county fields are so dotted with stones that deep cuts are an impossibility.

With the sun shining, there are tasks to be done before planting. Equipment that was carefully disassembled at the start of winter must be put back together. Hooking a spraying apparatus to an Allis-Chalmers tractor takes over an hour. In the meantime, cows let out in early morning crowd close around, pressing to get back into the barn. They sense a storm coming, though it is not yet in sight. Craig has mixed feelings. The land is dry and in need of moisture, but the spraying must be done well before the rain comes.

> See these cornfields? They're planted differently because the government had to go and mess around with Memorial Day. I was doing just fine, planting between rains, when it turned out the darned holiday was scheduled a week early. So my brother called and said he was coming up for the weekend with his family. Had to clean the house and didn't get my second field of corn planted. Can you believe it? I'm a week behind because of city relatives!

"How are you doing, my little soldiers? . . ." Kevin McCormick, more than six feet four inches tall, wearing knee-high work boots, leans over to inspect the pale-green shoots of corn just peeking through the red, rocky soil. "I'm busy, as usual, but it's good to be able to find the time to come up here and check them, to see how they're progressing." One field of corn, which climbs at a reasonable angle up a short slope, has shoots about six inches tall. In the second, on the other side of a graded road, it takes a double glance to pick out the new growth. Today's trip through the land came at the end of a busy, solitary milking. Kevin was a different sort of farmer, not married. He could sense his cow's needs as he paused and patted each before taking her twice-daily contribution.

Spring is a time of waiting and watching within the constant round of work. You must be ready to catch the first warm afternoons, to disk the fields, and then use years of prior knowledge to second guess the final frost. Cursed and blessed by the weather, it is like a game of chess in which plowing and planting are well pondered moves that must be made within the pattern laid out by spring rains. In this instance, a thunderstorm the previous night had been good for the young corn, but there was

potential damage to the dirt road leading to the upper pasture. A second-growth woodlot separated this from the cornfields, which had been cleared and in use for the past six years. In the underbrush, remnants of Catskill Mountain stone fences were continuous mounds, a memorial to unknown hands that had farmed here a hundred years before. The young trees surrounding them were an expression of the Catskills' resilience and a reminder that change is cyclical.

A stand of cherry off to one side would provide additional income for Kevin in another fifteen years. For him, the future offered a possibility that love of the land and the way of life might offset the downturn of the past few years. Farming remained a challenge, an experimental recipe of trial and error, eventually yielding just the right crop combinations to keep the bills paid and the cows producing milk at exceptional volumes.

The road he walked on now was none the worse for the past night's storm. It ended in an open area where knee high plants rippled tentatively in response to the early spring wind. It was a field of clover, taller than anyone who ever searched for four-leafed plants could possibly imagine. The blossoms were like pompoms on a child's roller skates, huge and purple, with the stems and leaves an unblemished loden green. One look confirmed that it was time to make a first cut of these fields sowed the previous fall. First cutting is a springtime marker, like planting. For farmers it confirms the continuity of growth after winter.

I had a meeting set with a farm woman who volunteers for county social services. There were three of us who were supposed to be there. At the last minute she called to cancel because she had to help get the hay in. The other person didn't understand it. If I'd said the woman couldn't make it because she had to work there would have been no question, but I guess farming doesn't count as work in some minds.

On a Sunday afternoon in late spring, the sun sheds a lazy heat over the mountain valleys. Church is over, and through the county, potato salad and lemonade begin to grace checked table cloths on backyard picnic tables. For the farm family, though, there won't be any weekend. The hay is ready to be cut, and as the humidity builds, predictions of early evening thunderstorms seem accurate.

In the narrow valleys of the Catskills, a key to survival is the ability to grow enough feed. Farmers work a magic that is a mix of management and intuition in order to grow high yielding, high quality hay and silage. A well-kept secret from one farm to the next, they watch each other's methods with feigned lack of interest. There is little talk about exact ingredients: fertilizer mix, cutting time, even when to let the cows out

to pasture. Yet it is these things that are the key to quality and quantity in milk production.

Kevin walks determinedly along the edge of his property, dislodging rocks and dirt clogs. The toe of his boot hitting the ground transmits the anger that he is feeling. "I've been looking at that farm across the road for ages. Good flat pasture, already cleared. I could have increased my corn and hay without any problems. Spent most of the winter talking with the old guy who owned it. He was ready to sell. I made him an offer and we shook on it. It was just a matter of getting to my banker this spring and arranging the loan. Nobody was in any real hurry. We'd agreed. Then, all of a sudden, he told me he'd sold to a developer. I don't know what they offered him, but it had to have been a lot more. Sometimes I think that the government has engineered the farm crisis around here in order to get back the land that they need to accommodate all the people from the already crowded cities."

Off the road, a young man works bare-chested on the edge of a newly poured concrete foundation. In a meadow that was pasture just last year, this is the second structure to be built in as many months. Throughout the region, building has begun again and land prices continue to inch up. Young farmers and land developers keep a cautious eye on those who seem likely to go out of business in the coming months. It has become a subtle battle, as those determined to continue farming and expand find themselves unable to purchase the adjoining farms that they've dreamed about for years.

> You stoke 'em from one end, and you clean up from the other. Twice a day. Every day. Three hundred and sixty-five days of the year. That's what dairy farming is all about.

An upstate New York farm town is often no more than a few blocks long. Entering from either side, woodlot and pasture give way to cornfields which separate houses as lawns might in suburbia. There white, shuttered, two-story homes sit like bookends to the village's mid-section, their age disguised by persistent neatness. Often, children's toys grace the well-kept lawns. Finally secure in the knowledge that the cold nights have ended, geraniums and begonias have been brought from indoors to add color and cheer to a wide, well-used front porch. Though attention and care are the hallmark of the main street, there are a disquieting number of "For Sale" signs. The absence of business and activity hints at what it must be like to grow up and anticipate the future to be spent here.

A small post office shares the town's center with a general-store-and-diner that is

the center for news and speculation about the events of the night before. Daily at eleven, eggs, bacon, and curly fries with gravy give way to hamburgers or tuna salad on soft white bread. Even so, if you try hard enough the waitress can be coaxed into serving one last breakfast. Next door, someone has begun to stir behind the dusty window of Andy's, where a lazily flashing Budweiser sign played host to thirsty townsfolk until 2:00 A.M. The tavern is watched, but not too carefully, by the square, white, clapboard presence of a Presbyterian church. It sits on a knoll surrounded by a small cemetery whose headstones range from weathered memories of the Civil War to this year's dead.

Nestled close behind the drowsy Main Street, a small farm carries on a never ending process. Approaching the barn, one hears the continuous hum of the bulk-tank cooling system. This is punctuated by the sound of the Surge milker which rises and falls with a pneumatic sigh. Inside, an ancient radio plays country-Western tunes with bursts of static that go well with the dust and cobwebs that coat its black plastic casing.

A friendly, but long-standing battle is carried on in the barn, where Jerseys and Holsteins occupy stalls on opposite sides. Bill, at 63, is impatient. He has been watching the sky with concern, waiting for the right moment to plant feed corn in the flat fields that border a small creek nearby. He is the keeper of the Holsteins, which produce more milk than Sara's smaller, butterfat-rich Jerseys. The couple's farming techniques are as different as their cows are. Bill is precise, depositing manure in the barn cleaner with a flat-bladed hoe, as he feeds and milks each animal. In contrast, Sara's movement is fluid. With a sidewise flick of a foot, her rubber barn boot acts as a shovel to push manure back into the gutter. Carrying through, she glides quickly to the front side of the cow with a bucket of grain, and then returns to position the milker, never once missing a step.

The Jerseys appeared ten years ago. Sara's five kids, born at regular intervals over a thirteen year period, grew up and left the farm and the town. Sensing a time for change in her own life, she took a job at a nearby feed store for a couple of years. Bill was not happy. He'd worked side by side with his wife since the time they were married, and though they talked little, he felt her place was on the farm. The Jerseys were a compensation when Sara finally returned to full-time farming. They were acquired two or three at a time. Now they number half of the thirty-eight milkers who occupy the barn.

"She's so much more a farmer. Mom always cared for the animals. I think she wanted to be a vet, but women didn't do that when she got out of high school." Lori,

at 37, is the middle child. She is a single parent who, like the other kids, left home as soon as school was over. She is now a source of pride for her mother, as she completes college on scholarship. Lori is an artist and a seamstress, who admits to milking perhaps one cow in her whole life. She never made a conscious choice between barn work and house work, but when the division came, she and an older sister stayed indoors while the two boys and the youngest girl took over the farm chores. For Lori, spring was always the time of mud. Brown, oozing, it was tracked all over, making more to clean up in the house. It was finally spring when the endless white expanse disappeared from the flat fields at the edge of the creek. Snow melt and steady rain would swell the tiny stream until it inundated the flood plain that reached as far as barn's edge. When the water in the creek was at last low enough, it was time for the family to emerge from the house and start the outdoor jobs.

"Dad could sense that I was growing up. When I became a teenager, I was too embarrassed to ride the wagon through town with him to mend the fences in the spring." Lori and the other kids looked forward to spring. After the mud dried, it was possible to hitch the tractor to the wagon and they rode with Dad deep into the farm to fix the fences. They all piled into the wagon, carrying wire, and posts, and the maul to knock them in with. On the way, Dad explained about trees and plants, and awakening an interest in his daughter that leaves her, to this day, gathering and drying wildflowers from wherever she travels. These are the best memories, buried for years under change and growth, emerging as her parents reach the point which, for most people, would be retirement.

Lori's father has aged recently. It has not slowed him down but some of the spirit is gone. The corn was planted this spring, as always, when it was certain that the flood waters were gone. But the farm is up for sale, in a town where small-city sprawl is moving rapidly to meet pasture. Yet is is time for the grandchildren to come out to the farm and groom a 4-H cow for show, replenishing the laughter and excitement that make milk checks more than just a living. Theirs are new young minds, eager to learn about trees and plants, as the wagon once again makes its springtime circuit through the town to fix last winter's fences.

Summer

AT 4:35 A.M., the July sun had not yet begun to rise over the well-kept farms lining Deer Creek Road. The creek itself, swollen with fresh summer rains, ran beside Paul Carter's barn, and he crossed it as he walked through predawn darkness on his way to an early milking. The creek was appropriately named. Fresh deer tracks dotted its edge each morning. Paul had developed a respectful acquaintance with the doe, and every morning he paused beside the rushing waters trying to sense her elegant presence. He knew that she kept a protective vigil over her two young fawns, limiting them to a grove far from the yellow backhoes which now carved small building plots out of the once unlimited forest. As he turned toward the barn he heard all three animals move across the water and the doe snorted once, letting him know she'd seen him.

Paul Carter milks 110 cows on one of the most efficient farms in the county. A hired herdsman usually handles two or three milkings per week, allowing Paul and his family the luxury of time off. On this summer morning, though, Paul works alone in his milking parlor. A collie pup races playfully through the lower center platform of the parlor, while eight cows file in to fill the four milking stations which line each side. They are lured into their places by the smell of fresh feed, deposited automatically in bins near either wall. As they reach their designated spots, their dark eyes look mournfully out above the level of the next cow. Each row is milked alternately, by machines positioned along the central recess of the parlor. The warm milk travels through the tubing, splashing down into five gallon pyrex-glass capsules with a churning force that leaves its butterfat almost ready to top off ice cream sundaes.

The first weeks of the month had been hot and humid. The corn, planted two months before, was thriving, as frequent rain and just enough sun had made it as tall as in any Midwestern field. As Paul and his son took the tractor and kick-baler to an upper field to complete first cutting of hay, cicadas called with a self-satisfied sound, announcing another day of record heat. On the road to an upper pasture, the two men passed construction equipment on its way to the new development. Paul sighed. "My oldest son's showing a lot of interest in the farm. For the first time, I don't know if I want him to be a farmer, at least not here in this part of the state."

The Carters were innovative farmers. A sign outside the bulk tank room announced "Clay Pushbutton Farming," and paid tribute to the studied efficiency with which the place was run. The milking parlor was twenty years old, one of the first of its kind in the area. Paul carefully considered each improvement, doing a cost-benefit analysis before making changes. Several neighbors had switched from traditional rectangular hay bales to a system in which massive cylindrical rolls were left to dry in freshly cut meadows. Paul described this as just a fad, arguing that spoilage easily ate up any real savings. On the other hand, he installed a manure storage system, and was now freed from the daily task of driving the heavily laden "honey wagon" to be emptied in a far pasture.

"There's twenty-four hours in a day, and I use most of them!" Andrew Lewis was farming as it has always been done, contrasting Paul's comfortable compromise of leisure and satisfying hard work. Though Andrew's routine for twenty years was to start the day before dawn, he still took pleasure in the intricate and unpredictable patterns that first light and sunrise often brought. His schedule left little time for recreation. It was packed hour by hour with what had to be done before the day could end, and was shadowed by the possibility of unexpected equipment failure. By mid-June, he looked trim and healthy from long hours of outdoor work, the deep brown of his "tractor tan" ending where his short-sleeved workshirt began.

At 11:00 A.M., the milking finished and the barn cleaned, he was awaiting the arrival of three neighbors so that they could clear the hay mow to store the first cutting. This particular loft was musty and smelled of one hundred seasons of haying. Though not as hazardous as the silo, it was still an obstacle course of accidents waiting to happen. It held the hay dryer, a source of slow warmth which removed the last moisture from slightly green bales. The dryer, the mow, and the hay bales themselves could be a fount of trouble. Andrew told of driving home on a dark night filled to overflowing with new-moon stars, to find his barn aflame. Working as he did sixteen hours a day in hazardous conditions, with little or no health insurance, was not unusual.

Kristin took a "First" with her Jersey calf. That's better than either of her older brothers did. We're really proud of her, but she was probably prouder of herself. She talked about it to anyone who'd listen all night long. That's what The Fair is all about.

Barbara stood with broom and mop in hand in the doorway of a small green and

white trailer. Though it was three days to the start of the County Fair, three of her four children had been consumed with preparation for most of the summer. For farm kids, the long months of vacation seldom spell boredom as they do for a city child. As school work gives way to farm work, early mornings will be spent helping in the barn. When chores are finally completed, hot afternoons are ended cooling off in farm ponds shared with frogs and salamanders. More than anything else, though, summer means the County Fair and all the preliminary 4-H competitions that kids use as practice for the actual events. It is a time when the family can take the trailer and a dozen of the farm's best animals to the fairgrounds. While camped near the edge of the dairy barn, they compete and visit with friends and neighbors from all over the area. Though back home the remaining cows still demand their daily attention, the Fair means that haying and other field chores can be put aside legitimately for at least a short while.

At midday, the two younger children were engrossed in vigorously scrubbing and brushing the hind quarters of the heifers they were about to show. The grooming would continue at a mechanized "cow wash" during the entire show period. Outside, Will, Jr., had gone to bring the tractor up from behind the barn. Barbara enjoyed fieldwork more than barn work and looked forward to driving the tractor through the fields. It was another clear, warm day. The hay had been cut for the second time yesterday, and was drying quickly in a nearby meadow. This morning Barbara would ted the lines of drying green clover, pulling the five groups of four spinning blades each to turn it.

"I'm needed here for support, if nothing else," Barbara said as she climbed onto the tractor, lifted her three-year-old son to her lap and headed towards the field. She and her husband Will rented the farm two years before, increasing the size of their herd and trying to make it work before the end of their five-year lease. He was an experienced farmer who had managed a large agribusiness operation before venturing on his own. Barbara had worked away from the farm until the previous fall, when she finally decided to return to full time farm work. This morning, young Michael rode only as far as the pasture's edge with his mother. Stopping the tractor, she lifted him down and sent him back towards the two-story white farmhouse. Then, shifting the lumbering diesel with ease, she turned off the dusty road and cut up a slope into the field. Her fragile but competent prettiness was enhanced by an air of contentment as she moved rhythmically back and forth turning the hay with the tedder. Overhead, three hawks circled lazily, keeping a detached eye on the summer's work proceeding below.

Now I asked each of these kids if they wanted to win first place, and they all told me no, they thought second. Except this young lady, who said she believed she'd like first, but she wasn't sure. So I've made my decisions. It's not this one; there's been a piece of straw on the brisket of this ewe all day. Well, first goes to the young lady who thought she'd like it. She brought that ewe right up in front of me, stood it square, and said "Here, buddy. Look at it!"

The full heat of summer descended early on the first day of the Delaware County Fair. In the impromptu trailer park at the edge of the Fairgrounds, families had been up from way before first light, milking their show cows and rewashing tails to get them ready for the day's judging. In the sheep barn, a young woman was lost in concentration as she made a final inspection of her ewe's well clipped, wooly black feet. These jobs completed, some families reached into ice chests laden with breakfast foods, while others wandered over to a nearby yellow and white canopy for a meal of pancakes and eggs served with real maple syrup by members of an enterprising Methodist congregation.

The County Fair has two personalities. On one side, cows, horses, sheep, pigs, rabbits and chickens are housed in pens and stalls under long, open buildings. They moo, bleat, snort, and crow symphonically. Interspersed with these are displays by farm implement dealers showing twenty thousand dollar tractors. Here, salesmen from Massey-Ferguson glance suspiciously at a fleet of equipment bearing an unfamiliar Japanese name. Close to the entrance, unmoving, humid air fills wooden buildings where quilts, jams, vegetables, crafts, and artwork are judged by representatives of the Grange and 4-H. For the young people, ribbons won this week reward hours of work during the long winter months. They are displayed with pride throughout the year in barns and kitchens around the county.

The carnival is the Fair's other guise, a wonderland of cotton candy and jellied apples which comes to farm country but once a year. As they walk through the farm displays, young children can be seen pulling at their mother's arms. They lead the family towards the games and rides hastily assembled by carney workers who have seen one too many counties by late August. It is an opportunity for fathers who were high school baseball heroes to impress their children, winning brightly colored stuffed animals for each of them. Youngsters, whose darts seldom pierce three balloons in a row, are lured by poorly scribbled signs announcing a limit of two prizes per player.

A reviewing stand looks down on the Carousel, Tilt-a whirl, and Swings and on the colorful striped tents across the way. Dense white barbecue smoke lingers above their gay peaks. On the track below, local men with hats that advertize tractor brands,

flannel shirts, and ample bellies wipe their hands on rags hanging from their denim pockets, as they wait to begin the afternoon-long tractor pull. Spectators converse at scream level above the roaring engines, eating chicken, hamburgers, or sausage and pepper sandwiches. Later that night, the Demolition Derby will present the destruction of rusting Oldsmobiles and Pontiacs, cars that most teens would be pleased to own. On the Midway, city folks up for the summer carry no mud or manure on their sandaled feet. They are easily distinguished from farm people as they wander from the Midway to concessions and crafts shows. Unable to sit for hours on the edge of a livestock show ring, these seasonal visitors miss the thrill of winning and know little about the excitement and satisfaction that is farm summer and the Fair.

> A lot of folks think I'm crazy, expanding at a time when so many of them are going out. Well, seems to me that the only way to make money these days is to do something nobody else is doing. So we're building a new barn.

Odie was the self-appointed overseer of the new construction. Rust-colored and white with a silky coat, he looked like a mix of retriever and cow dog as he weaved back and forth through the massive frame of a barn that would eventually hold sixty-six cows. It was mid-August, still summer in most parts of the state, but on the tops of the surrounding hills a few trees taunted the barn builders with orange and red-leafed branches. When the warm sun ducked behind one of the frequent clouds, the nip in the air was like an alarm that pushed the three workers to move from leisurely banter to a concentrated effort.

Like a tightrope walker, Jim moved across the 2×6 that formed the main support for the peak of the barn's roof. Odie barked determinedly to remind Jim's two sons that they needed to be ready to receive the beam that their father was carrying across a narrow platform thirty feet above the ground. The barn was a free stall addition to the graying structure beside it. Built in 1970, the old building now housed thirty-three cows that would form the nucleus for the larger herd. The farm was reestablished by Jim in 1969 on land that belonged to the family in the early part of the century. Behind their construction was the image of the family farm as it had once been and could be again, run by Jim, the older son and his wife, with two grandchildren growing up to learn a peaceful yet frenetic way of life.

In the distance, a giant crane was raising the steel skeleton of yet another massive electrical tower. Wider than a four-lane highway, the towers marched over the hill in steady progression, testimony to a battle lost by local farmers who argued that the

electricity from the high voltage lines would affect their cows and lower milk production. More immediately, the line consumed acres of woodlot and pasture, and in many places cows now grazed between the girdered legs of the giant towers. On Jim's property, the state's bulldozers cleared seventeen acres of hardwood, leaving it as debris lining both sides of the gaping cut. For Jim, the pine and cherrywood downed by the infamous "powerline boys" became the harbinger of tomorrow; he had had it hauled to a local mill and hewed into the beams which would soon be the new barn and the future. Working today in the slow spot between summer haying and fall harvest, there was a satisfied feeling in the air, as father and sons paused to drink iced tea and Odie wagged his short tail.

Autumn

In late September, a plum-red maple sits like a sentinel beyond a gray barn where morning milking has just begun. The tree is outlined against a dawn sky mounded like cream silk that has been dyed soft orange and turquoise. Sunlight falling in tentative rays teases farmers who are waiting with limited patience to fill silos with the final load of second cutting hay. By 8:30 though, when the indoor chores are done, the sky is gray and all hint of clear fall crispness has vanished.

Between the low, rounded ranges of the Catskill Mountains, September "line rains" are a plague to farmers racing to complete outdoor work during a deceptively short autumn. These steady downpours are born of continuous fronts that blanket the area, inspiring comparisons to other falls and the annual conclusion that this one is the wettest year ever. Though by midmorning the ragged charcoal clouds will give rise to hazy overcast, the rain is just enough to soak the hay that dried off in last evening's burst of sunshine.

At the tops of the hillsides the second growth woods that edge the morning's dripping pastures are lined with a moldering carpet of early fallen leaves and moist mosses that give beneath the hooves of two wandering heifers. Golden and purple are the last vestiges of color in unmowed fields; blackberry brambles fill the spaces between trees felled for firewood. The fences are slipped piles of bluestone that mark last century's boundaries; further up young planted pines sway gently in response to a slow breeze.

The doe has come out of the woods to graze beneath a single apple tree that is heavy with sweet, ripe fruit. Her young are now half-grown and all will soon abandon the farm's borders as the summer's truce ends in autumn's yearly hunt. Startled by the doe's movement, a pair of partridges take off in low-level flight. The whirring of their wings signals fall in the woods, just as the constant hum of tractors and choppers signals fall in the fields.

We used to have four silos, till one rainy autumn we filled one with corn heavier and wetter than usual. It tipped over and fell, like a few others around here that year. So we

33

put in the bunker system. It may get uncomfortable hauling in the silage in wintertime, but it's better than climbing up silos to fix things. Whenever you got machinery, you always got breakdown.

In the Butternut Valley, a dense early morning fog has burned off, revealing a rare, bright fall day. The sunlight sparkles on four red geranium plants hanging outside the milkhouse, signs of a woman's touch. There is a corn chopper parked near the long freestall barn, but in the cornfields that ring the farmyard only the first eight rows of browning stalks have been cut and chopped. Two oily, stripped gears lying on the steps leading into the barn explain why the job has been interrupted.

Before October's Indian summer sets in to ease the heavy moodiness brought on by constant drizzle, farmers work continuously against the twin nemeses of machinery and climate. For the Stevensons, a Cornell educated father and son team who run a farm that has been in the family since the last century, corn chopping has begun early, so the breakdown is not as threatening as it might have been later in the season. Their farm is deceptive. From the road, a well-kept white house, with silos reaching up in the background, gives the air of quaint smallness. Once around the back, however, a series of vast barns are testimony to the fact that it is one of the largest single operations in the area.

The free-stall barn that houses the 114 cow milking herd is an imposing structure of concrete and unstained rafters. At one end stairs lead to an upper gallery which overlooks lines of Holsteins along the sides of a massive floor space. Ray, at 72, is the senior member of the partnership. He's worked the farm since 1936, and this morning drives a small tractor with a loader attached down the center of the barn in order to clear it of manure. The cows are milling around behind fences which keep them away from the feeding area. They know when breakfast is about to begin and so there is little grumbling as they wait for the wide doors at the far end of the barn to swing open. Peter drives a "Little Auggie" feed spreader along the fifty yard long troughs, automatically dumping feed regulated to meet the specific needs of each set of cows. They have just been milked in a twelve stall milking parlor by a herdsman who has worked the farm for over a decade.

"Feeders are high maintenance, and fairly slow, but silo unloaders don't work, especially in winter when stuff freezes to the sides. Bunkers are maintenance free and cheap," Peter said, as he drove outside the barn to pick up another wagon load. The feed, a "tossed salad" of corn silage and the chopped grass known as "haylage," is currently being stored in two large cement bunkers just beyond the doors of the main

barn. The bunkers are three-sided and are dug into a soil bank that leaves them largely underground. A small front end loader fills a feeder cart from the open end of the trench that is now in use, and walking across the upper surface of the chopped corn is like balancing on a spongy mattress. The second bunker is sealed shut with large sheets of shiny black plastic held down by old tires and accented by purple asters which grow with a delicate curl over the edge.

On this weekday morning the farmhouse is closed up silent behind drawn curtains. A trace of woodsmoke hangs in the air, but neither wives nor children are home—off-farm jobs and school occupy their time. The children help in the barn from time to time, but in the fall their afternoons are taken up with sports, music, and other afterschool programs. There was a time when farm kids didn't think they had to do what the townspeople did, a belief geared as much to the fact that no one in the family would have been available to chauffeur them home from games and concerts at such odd hours. Now, the existence of late-shift school buses has merged with family insistence that children are entitled to a more rounded life. Though this farm operates with calculated efficiency, based on care, love and constant planning, the four Stevenson children have grown up with the sound of the farm crisis around them. Peter fears that their perception of farm life has been colored by family discussion of rising prices and falling profits over the last eight years, and he would be pleasantly surprised if one of them chose to enter the business after college.

Farming's sure a different way of living. I'd been in a barn once before I got a job milking. Worked over at another farm for a year before I came here four years ago. There's no comparison!

The sky over Croton Farms was washed clean by an early shower as the midday sun turned pre-winter back to autumn. As the spreading blue pushed the morning off into the distance, the steady sound of whirring diesels began to echo back from the upper fields which are only a fraction of the farm's 600 acres.

Individually, each of Croton's seven farms are larger than most found in the county. Operated by a small army of salaried employees, the farms all have enough cows and acreage to justify investment in machinery and methods that could not be used with smaller herds and less land. Earlier, the eight-wheeled New Holland corn chopper had made steady progress through bands of contoured cornfields interspersed with strips of blue-green clover. It was a precision dance, as blue tractors pulling red trucks docked beside the yellow chopper. The browning corn stalks were pulled in through

the front, chopped into silage and spit out through a chute into the continually moving wagon. Clouds of corn stalk, picked up by the wind, floated moth-like in the muted sunlight. As each wagon filled to overflowing the chute rotated 180 degrees to repeat the dance with a twin approach from the other direction. In the chopper's wake, the corn stubble spread like stones in a military cemetery, spiky monuments to this year's production. The chopper, with its wagons attending, turned and paused momentarily. Taking advantage of the quiet, three deer broke from the uncut corn, walked into the clover and drank the raindrops clinging to each plant. Finished, they raised their heads, and looked cautiously at the lumbering machinery which had invaded their domain.

On the county road which runs between Croton's scattered farmsteads, silage wagons pulled by tractors move with single-minded determination. Motorists have learned to drive with care during the chopping season, as the highway fills with farmers who demand more than sixty minutes of every hour. The time to cut is when the ears of corn have turned orange and the cob is almost purple. Each kernel has a shallow dent in its edge and no longer bleeds a thick milk when pierced. At this point, when the level of protein and nutrients is highest, corn should be chopped and stored—if only the rains would stop, if only the sun would shine, if only the tractor dealer would stock the part that went out on the tractor a few hours earlier.

A Croton wagon pulls off the highway and heads uphill toward the long white milking barn of the home farm. The driver pulls the wagon up next to a towering concete silo. Adjusting the red bandanna that holds his long hair captive, he watches carefully as the rotating auger moves chopped corn from the truck into a hopper from which it is sucked up into the silo. In the barn the young couple in charge have begun afternoon milking early. As Maggie feeds grain to the continuous lines of well-kept Holsteins, a newborn calf struggles to stand for the first time. Sunshine filters through the open door at the distant end of the slightly curving barn. It puts a spotlight on Cal as he drives a three-wheeled cart, spreading sawdust along the length of the concrete floor. The cart comes down the center with a dull roar, making the cows seem like fidgeting passengers lining a subway platform at rush hour.

Parked near the barn door is a 4-wheel drive station wagon. Inside its open hatch are eight graduated glass cylinders calibrated to measure the amount of milk produced by each of the 122 cows on the farm. The car's owner is the milk tester, who comes once a month to keep track of quantity, bacteria count, butterfat and protein content. The stacks of computer printout sheets which tell the story of every cow are only a fraction of the meticulous record keeping that goes into running a good farm. At

Croton, a central business office orchestrates the collection of breeding, feeding, production, and financial information. On the small farm, the job must be done by a family member in the all-too-fleeting space between dinnertime and sleep.

"It always takes us a half hour longer to milk when you come!" There is good-natured joking between Cal and the milk tester as they monitor every cow's performance. Though Croton replaced six farms that once belonged to individuals, it has become a huge extended family to those who now work and live there. From the milk tester to the soil conservation people who keep track of the farm's attempts to halt erosion, there is an air of respect for an operation that supports not just twenty-five families but the surrounding farm communities as well.

> Work a forty-hour week? We do that by about Wednesday! As a farm wife, the first thing I did was to put in an eight-hour day in the farm operation. If I did any housework, it was an afterthought.

The blue walls of the milkhouse were the color of a robin's egg, a pleasant change from the usual whitewash, though here it didn't seem out of place. When you've been farming in a place for as long as Walter's family has, you've earned the right to take some liberties. He is the fifth generation to work the land which has been theirs since 1807. In the distance, the sprawling form of the original white farmhouse caps the top of a low hill, its eight-paned windows reflecting early morning light in rippled glass.

The farm was started with fourteen cows. During the nineteenth century, and well into the twentieth, milk was poured into tall metal cans, the kind that now holds begonias on suburban doorsteps. In the era before refrigeration units and bulk tanks, each town had a creamery, and the milk was picked up daily from the farms, first by horsedrawn carts and later by trucks. Walter found it amazing that so much of the job had been mechanized. Change, like his aging, had come gradually, almost imperceptibly, season by season, year by year.

In the early twenties, the depression hit the farmers before it hit the rest of the world. Walter's family held on, first adding a Delco line generator for milking, switching next to a dumping station, and finally to the pipeline. Once you started adding cows you had to have a barn cleaner, and once you had a barn cleaner you had to have a spreader, and once you had a spreader. . . . The first tractor on this farm had been bought thirty-seven years ago, a partial replacement for the work horses used for plowing and planting before that time. You had neighbors then. The peaceful valleys

of the Catskills were dotted with small family farms now remembered only when a hiker pauses to reflect on a half-buried foundation deep in hillside woods. With the passing of time, the farmer could not make a living with a small number of cows. Just as it is today, you had to get bigger or get out.

To Walter's wife, as to most farm women of the forties and fifties, working off the farm made little sense. First, she had the chickens to care for and the eggs to gather. Then, there was the butter to churn and the garden produce to can. Her constant activities around the farm helped provide for the family's needs, just as today her daughter's wage brings in cash on a steady basis. Mornings, she delegated chores and tasks to the children, sending some to the barn and some to breakfast—and it wasn't necessarily a boy outdoors and a girl in the kitchen. Eventually the children grew up, and some stayed in farming while others moved to the cities.

Now, a son and a daughter-in-law remain with Walter on the farm. Together they milk sixty-six cows, working with a hired herdsman who has been with the family for five years. In the last decade, as the cry to expand or perish echoed through the county again, Walter selected conservatively from the high-tech, high-dollar array of innovations. "The pipeline saved me half an hour on every milking, and the automatic line washers were worth the investment. But I've still got a conventional silo, not one of those airtight blue monsters you see everywhere. You know what those things do that my silo doesn't? They put you in debt!"

"As you get older, I guess you do things easier, partly. Nothing's permanent, not even people." Walter walked across the farmyard to the house, oblivious to the dark autumn mud that filled the space between. At 7:00 A.M., it's early enough for Walter to eat breakfast and watch his granddaughter leave for school, carrying her musical instrument and volleyball shoes. She will travel to a school faced with closure, through a valley where one hundred farms have dwindled to eighteen, a town where there is no longer a creamery or even a feed store. After bacon and eggs and two cups of coffee lightened with the rich Jersey milk just drawn from the bulk tank, Walter goes after the boots he left in the mud room. Located just outside the kitchen, it is fragrant with the essence of aging beams, 4×6s held together with huge nails that show little hint of decay, just as the farm shows little hint of slowing down. The rest of the morning will be spent filling silos with corn. Two weeks from now when all the corn has been chopped and stored, it will be time to stable the cows. Then the barn chores will increase, and the trees will be bare, and Walter and his son will finish cutting wood, as the last summer day of autumn becomes the last autumn day before winter.

Been a lot of changes and some of it for the best and some not so good. You have to take change as it comes. I've seen the ups and downs two—three times in my lifetime.

The leaves of autumn rose like a forest fire along the low ridge across the road. I was sitting by a small pond, which was filled to overflowing by the recent rains, wondering if all the frogs of summer had already burrowed into the warm mud. There had been ice on the car a few mornings before, and I'd found a red-bellied racer coiled in a stupor under the edge of a tarp. As I stood warming the tiny snake in my cupped hand, I called out loud to the forces responsible for turning fall to winter. "I'm not ready for this!" But it was more than just the change of seasons that I was mourning.

Almost a year had gone by since that snowy November daybreak when we'd inched my brand new 4-wheel drive over the mountain to the Crawford farm. The car was now dusty and a little battered from 10,000 miles of back roads leading to upper pastures and farmhouses nestled in comforting settings. The hundreds of photographs of people who had willingly opened their lives to us were like a road map through a year of growth and change, not just in the farms and farm communities, but also in the anthropologist and the photographer who had tried to document them. There had been afternoons when I drove back home to my house in town and my job in town with a sense of perspective and of peace that could not be found in years of psychotherapy.

The all-too-frequent farm auctions around the county had become a bittersweet setting in which we'd seen many of the farmers whose barns and homes had played host to us over the past months. It was an opportunity to hear how each had fared, to take up the story frozen in time in a black and white image during our earlier visit. Many were optimistic, seeing at least partial recovery in higher cattle and milk prices and in a year of record harvests. For others, winter would find "the wind blowing through the barn" as months of hard contemplation ended in the decision to sell. A late fall auction would mark our final visit to Kathy and Steve's as a working farm.

Two days before we had headed out for our final day of shooting. The skies had cleared the night before, and as we paused to re-examine the abandoned house, a torrent of yellow leaves danced for a moment on swirling breezes. The cat had deserted his wintertime boudoir, but the house was still standing, arched at a belligerent angle in spite of seventy-two inches of snow last year. Nearby, the bare-chested house builders of the summer sun were clothed in different plumage, wearing flannel shirts and down vests and working feverishly in the shortened space of daylight. We'd stopped for breakfast, connoisseurs now of eggs and fries and hamburgers and fifty-

cent drafts served at small diners all over the county. As we rounded the crest of a hill and started into a half-chopped cornfield, I realized how in just one year this land had become my closest friend. It took little to imagine what it would feel like to have farmed it for generations.

I stood at the edge of the corn stubble and watched as the photographer perched on the hood of a moving tractor, shooting continuously. The farmer who was driving turned off the diesel, and together we walked down towards the barn, sinking ankle deep into the mud at every step. "The kids are all in college now," he told us, "so for Marge and me the days are getting longer and the nights are getting shorter." In spite of this, he was considering adding fifteen new cows to fill a second barn that he had bought down the road, "So, what do you think you'll do?" we asked. "Expand or hold your ground?"

Overhead, two red-tailed hawks were swooping low into a grove of orange maples. The farmer shook his head and frowned as he squatted down and crushed some of the soggy earth between his fingers. "It's hard to call. Overall, the signs are good, at least better than they have been. But Delaware County's a different ballgame, with all the development going on. I don't know. Still, we'll figure something. Can't dance, too wet to plow."

Looking up, he broke into a wide, engaging smile. "But then, we don't plow in the fall anymore, anyway. We just wait for springtime."

Winter

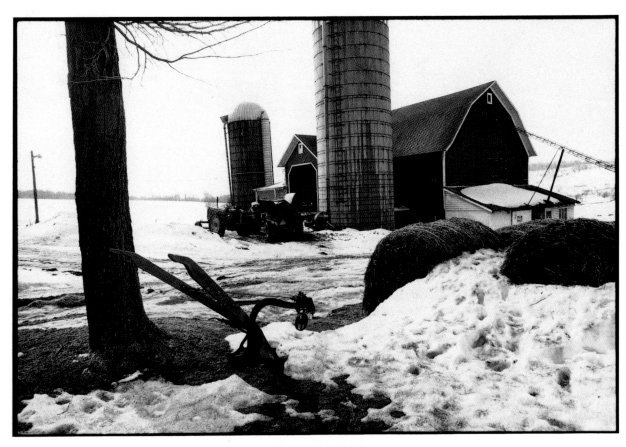

WINTER PAUSE ON THE CATSKILL TURNPIKE
Delaware County

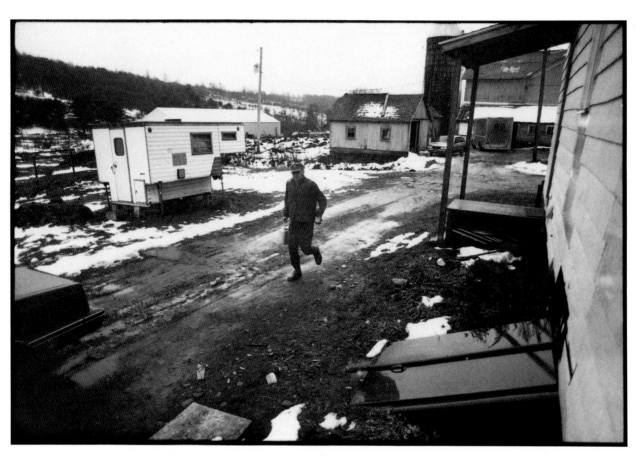

BOB AVERY, SR.
Meridale

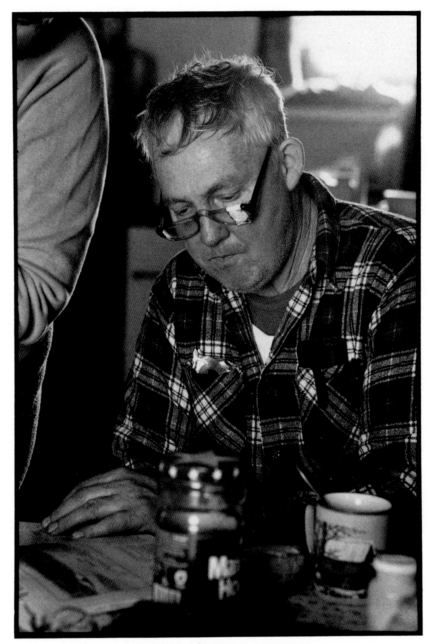

AFTER MORNING CHORES
Elk Creek Road, Delaware County

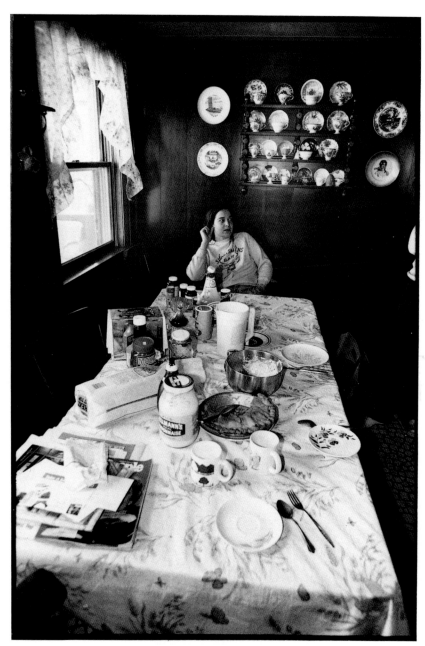

FARM BREAKFAST
Masonville

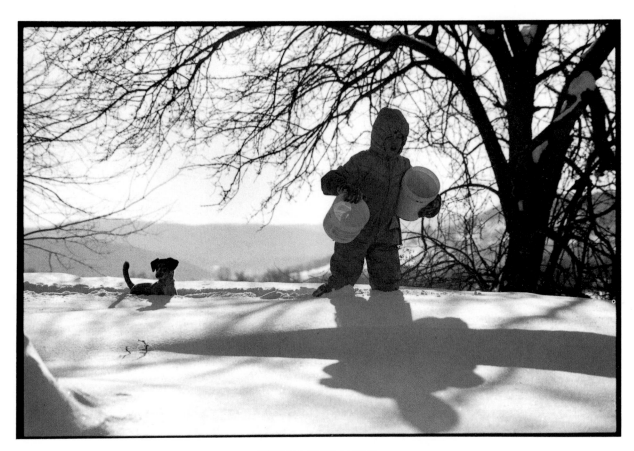

GOING FOR EGGS
Delancey

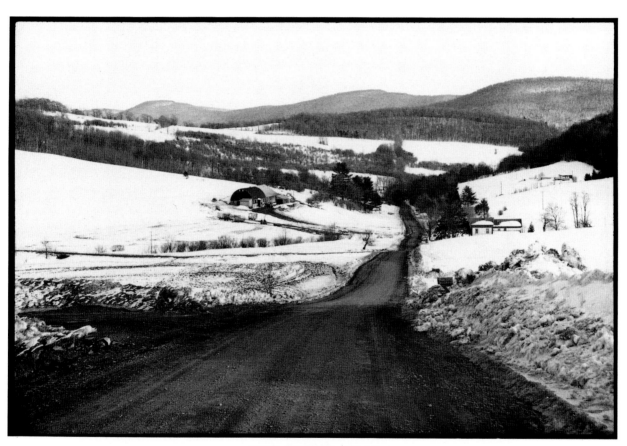

KIFF BROOK ROAD
Bloomville

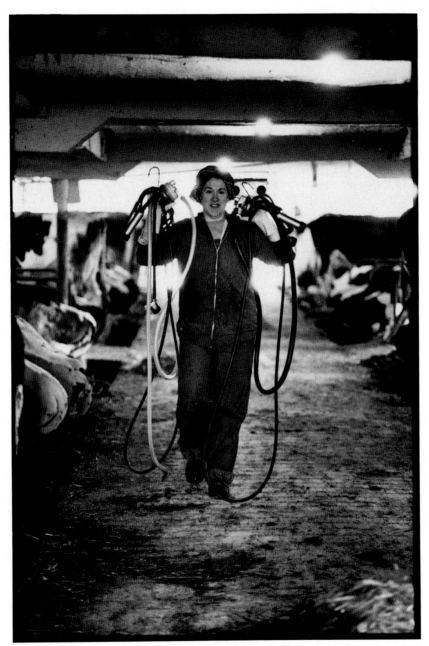

MILKERS
Delhi

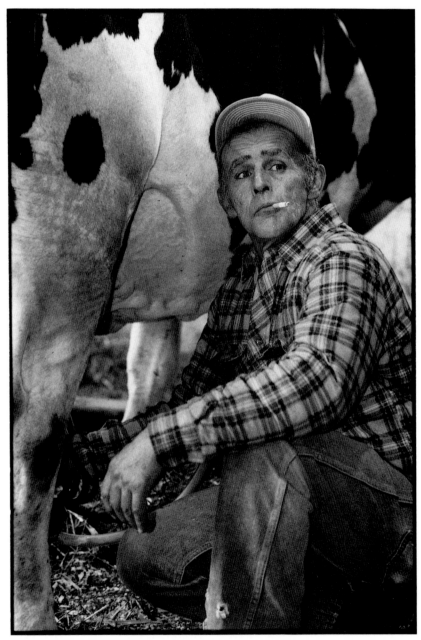

HAROLD SMITH, SR.
Bloomville

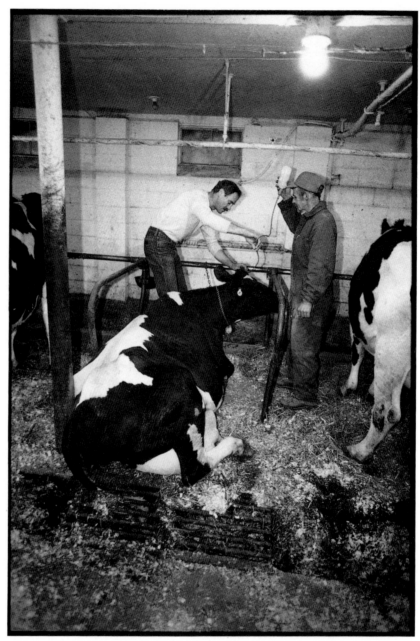

VETERINARIANS MAKE BARN CALLS
Bloomville

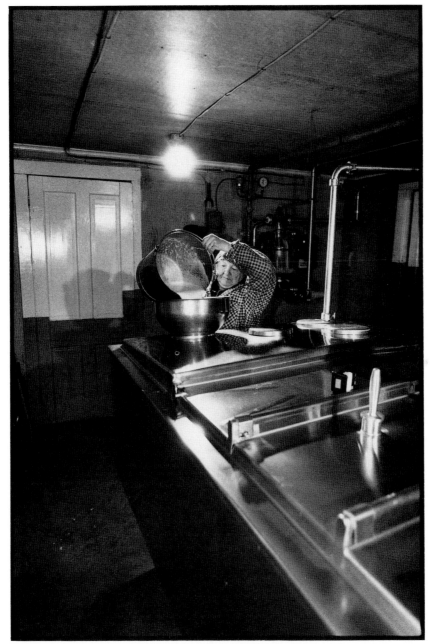

FILLING THE BULK TANK
Meridale

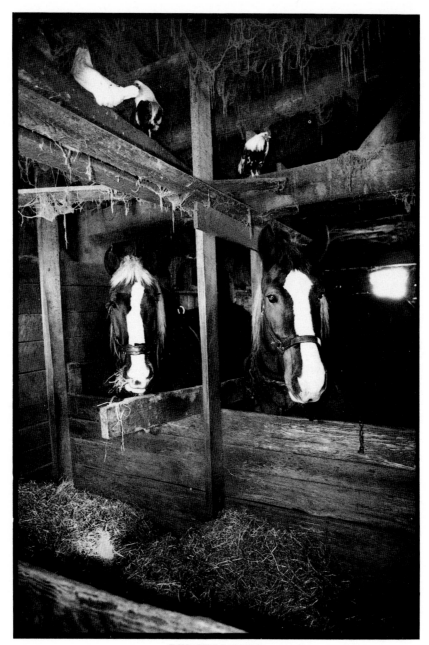

BEDFELLOWS
Delancey

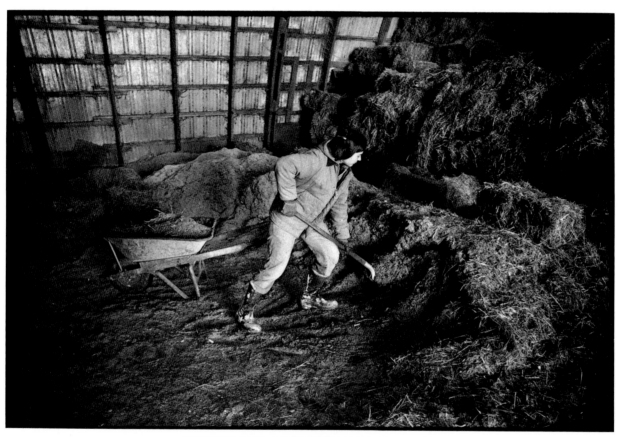

SHOVELING SAWDUST FOR BEDDING
Masonville

AFTER MILKING
Meridale

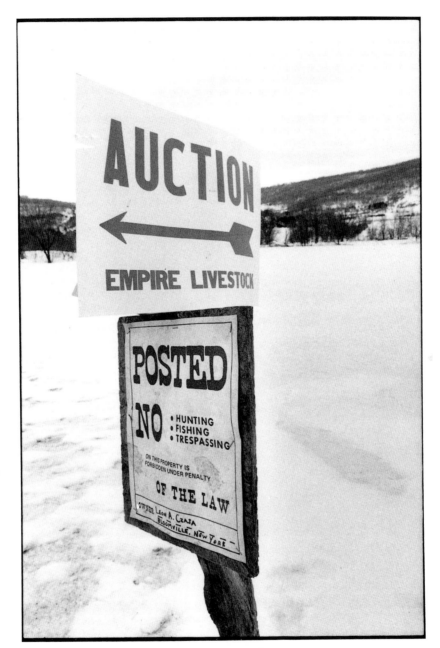

FARM LIQUIDATION
Bloomville

DECISIONS
Farm Liquidation Auction, Bloomville

AT THE AUCTION
Bloomville

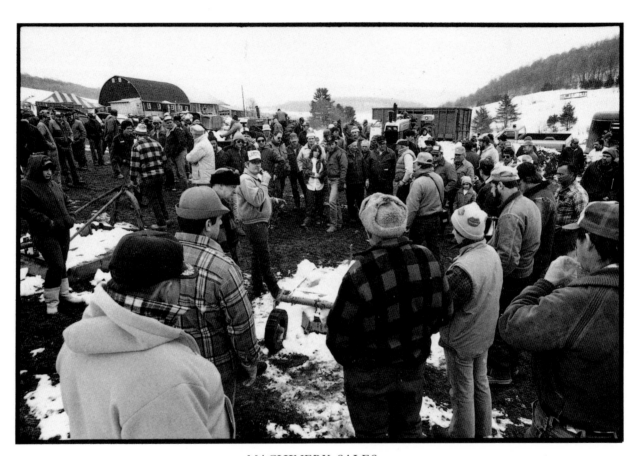

MACHINERY SALES
Bloomville

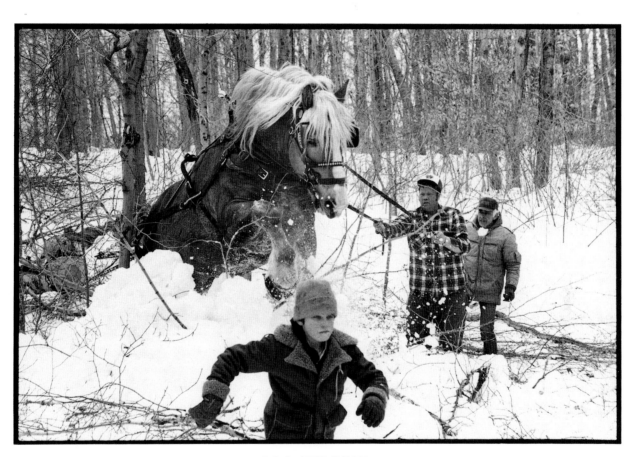

LOG SKIDDING
Cherry Valley

SAP BUCKETS ALONG THE CATSKILL TURNPIKE
Meridale

ABANDONED FARM HOUSE
Davenport

Spring

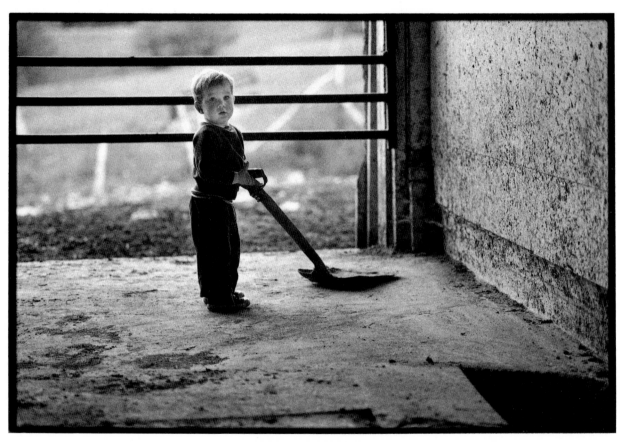

SPRING CLEANING
Stamford

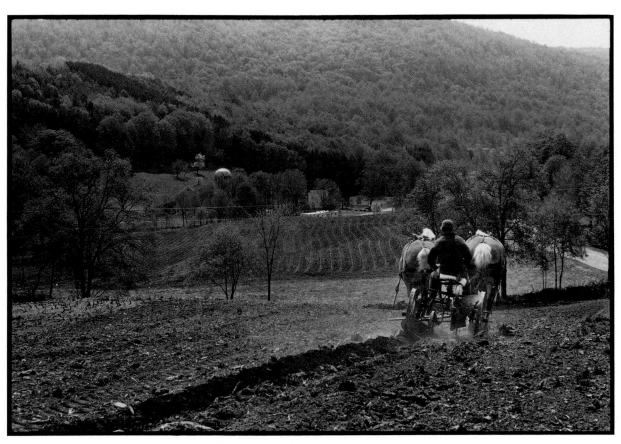

PLOWING WITH WORKHORSES
Elk Creek Road, Delaware County

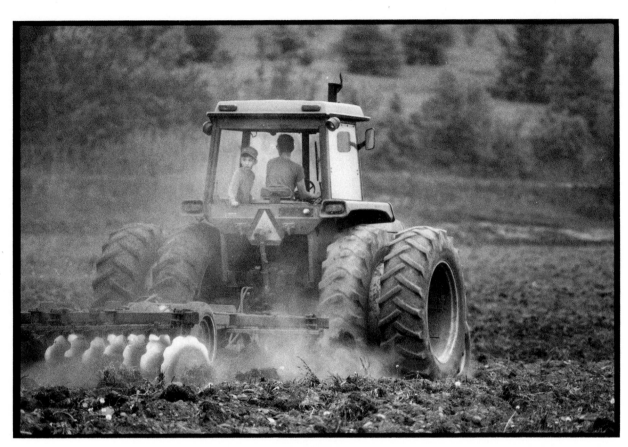

DISKING
Delancey

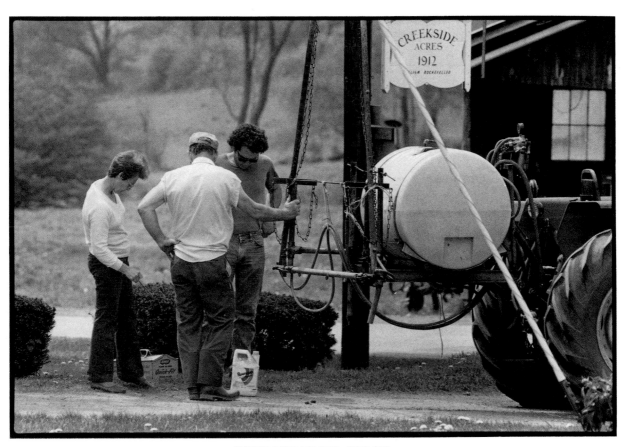

PREPARING TO SPRAY
Delhi

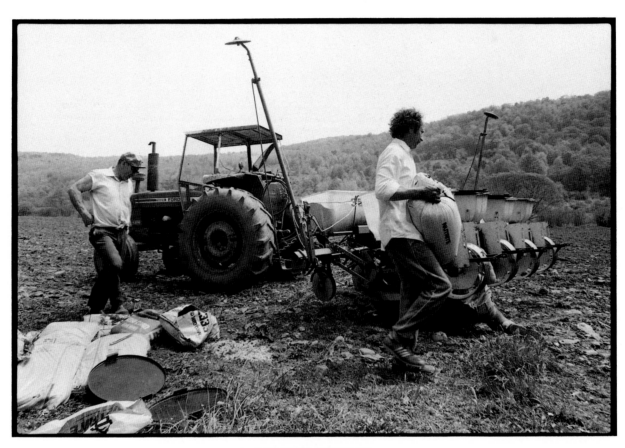

CORN PLANTING
Delhi

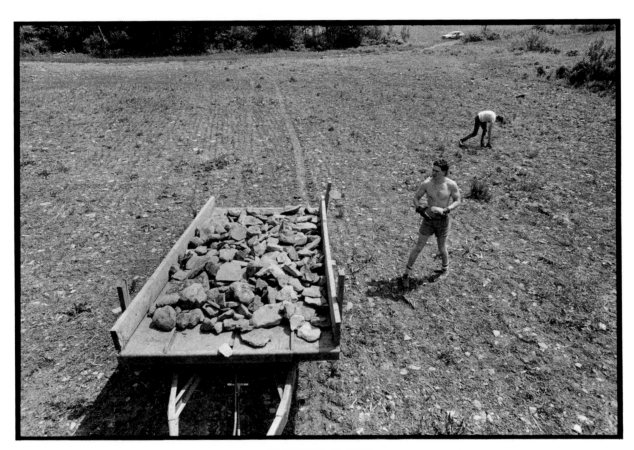

PICKING ROCK
Delaware County

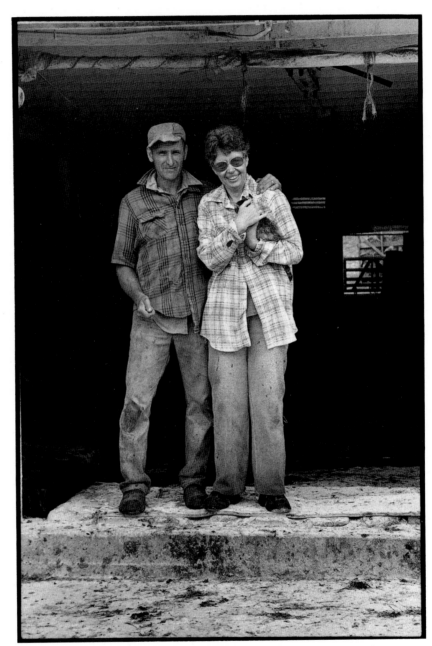

FARMING TAKES A COUPLE
Delhi

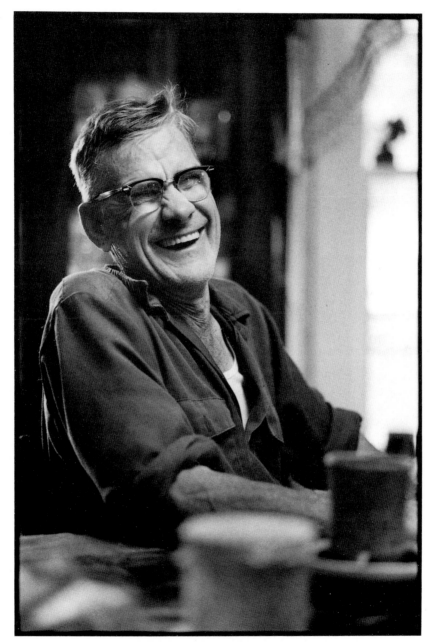

GEORGE DANFORTH, SR.
Jefferson

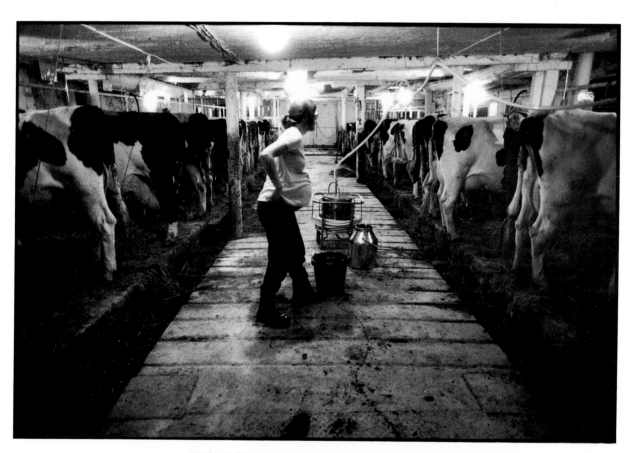

THE DAY BEFORE THE BABY'S BIRTH
Meridale

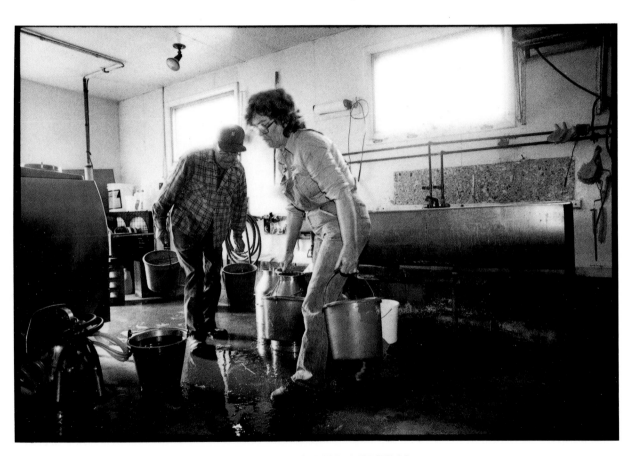

CLEANUP AFTER MILKING
Laurens

BARN KITTENS
Delaware County

TIME TO EAT AFTER MORNING MILKING
Jefferson

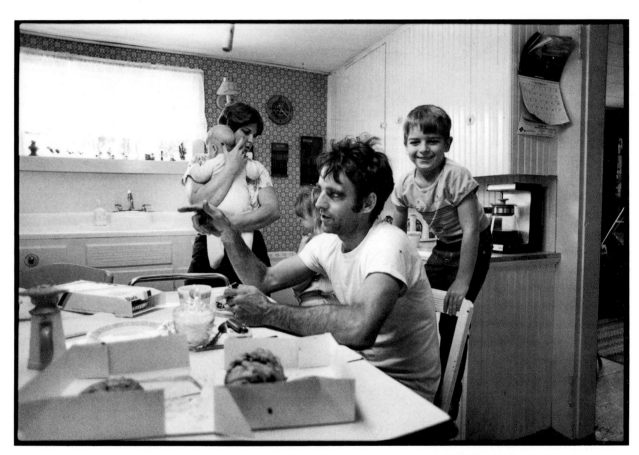

FARM FAMILY
Andes

POSTMISTRESS
Delancey

MEMORIAL DAY
Treadwell

SUNDAY IN EARLY SPRING
Coventry

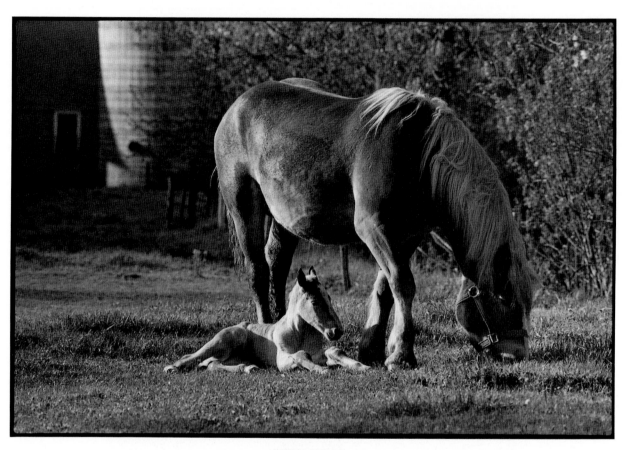

NEW FOAL
Delaware County

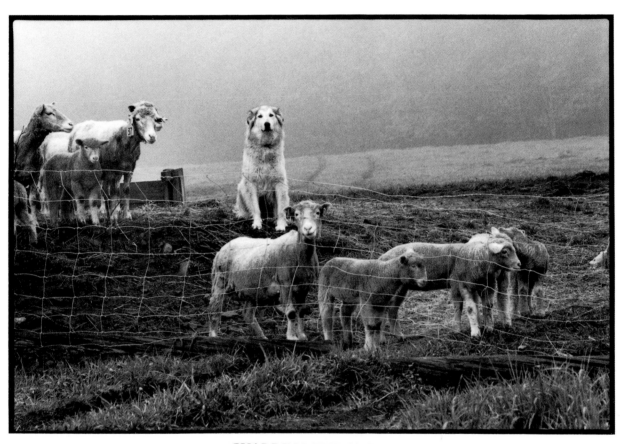

GUARDING THE FLOCK
Delaware County

Summer

FOURTH OF JULY SILO
Oneonta

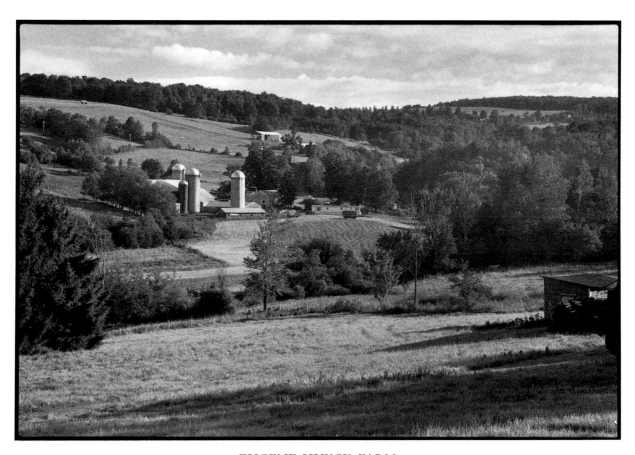

EUGENE HUYCK FARM
Treadwell

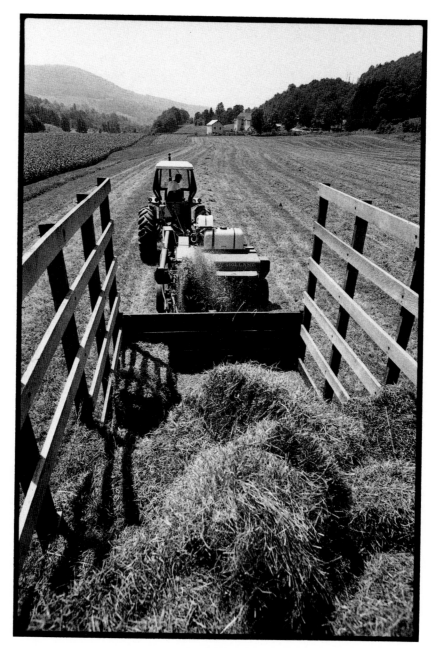

HAYING
Elk Creek Road, Delaware County

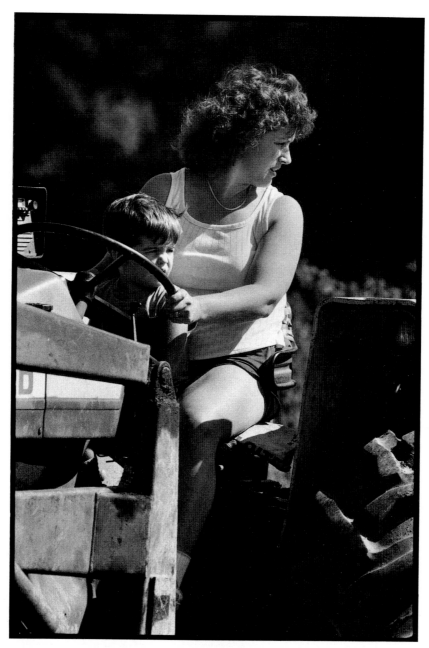

TEDDING
Delhi

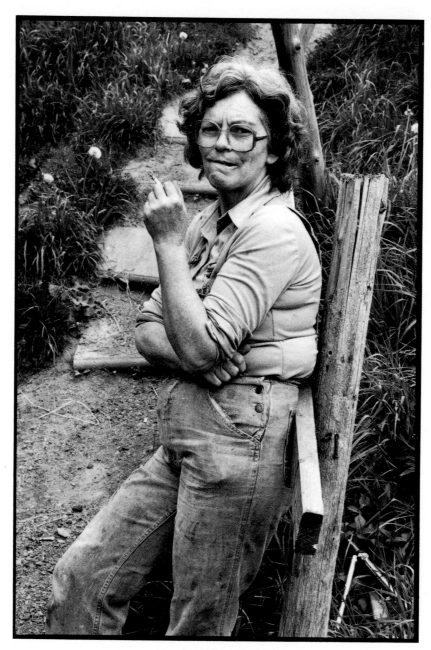

AGGIE LOUDEN
Laurens

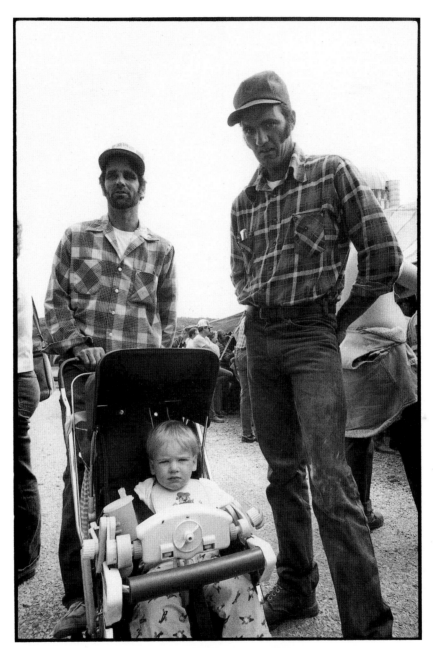

OUT WITH THE BOYS
Farm Auction, Andes

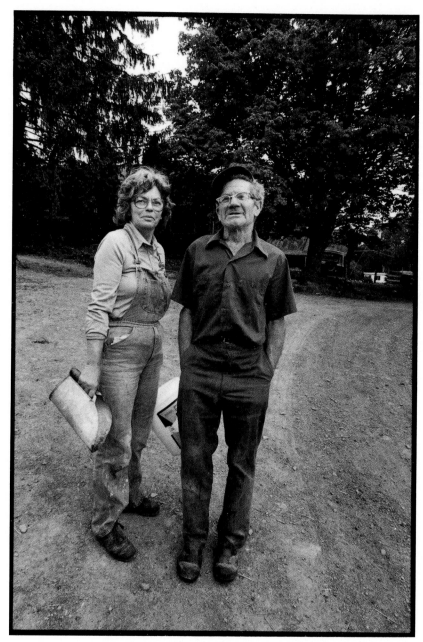

READY FOR MORNING CHORES
Laurens

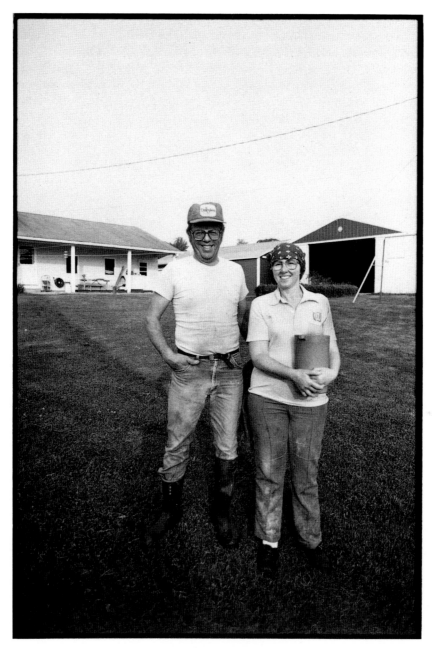

FARM COUPLE
Mid-morning, Delaware County

TALES OF THE PAST
Milford

TALES OF THE PAST
Oneonta

AFTER MILKING
Delhi

CHURCH SUPPER
Treadwell

THE SOCIAL SIDE
Farm Liquidation Auction, East Meredith

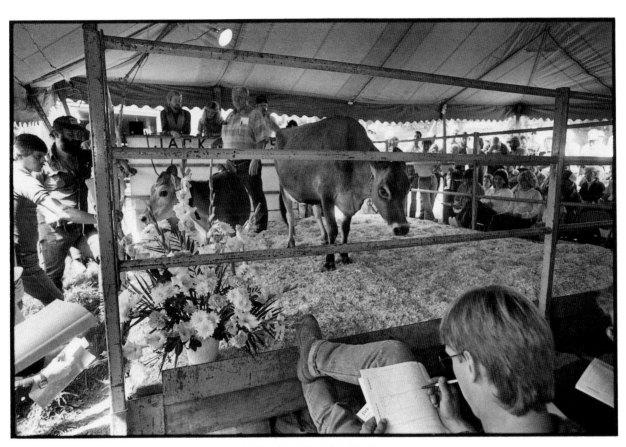

THE BUSINESS SIDE
Farm Liquidation Auction, East Meredith

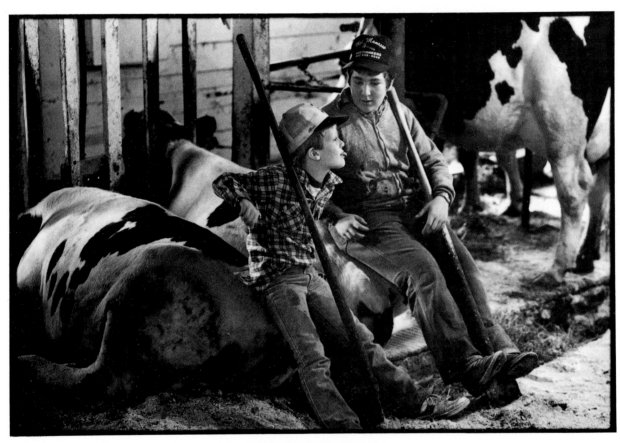

CARING FOR COWS
Farm Liquidation Auction, Vega

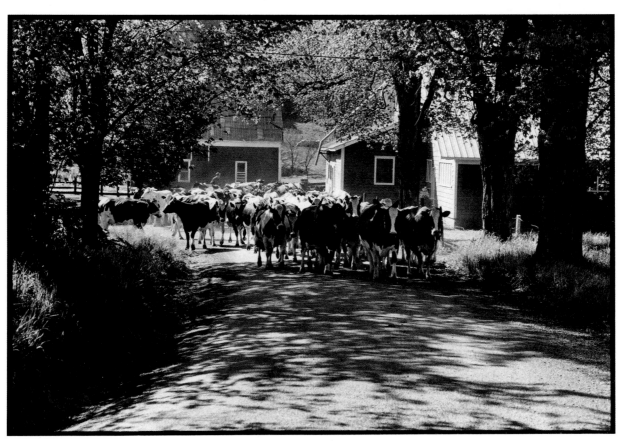

DAY'S END
Delaware County

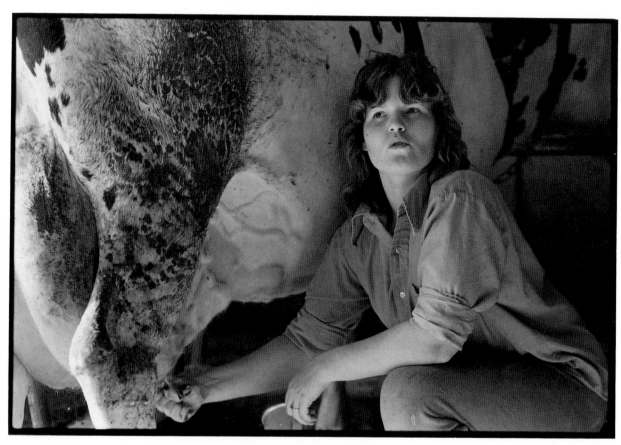

PREPARING TO MILK
Stamford

JERSEYS
Delaware County

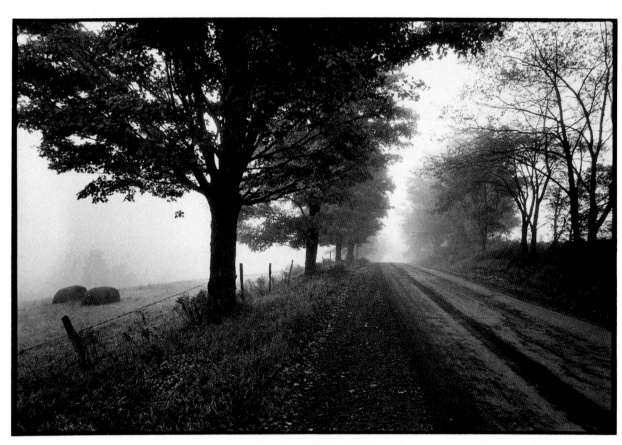

CATSKILL TURNPIKE
Meridale

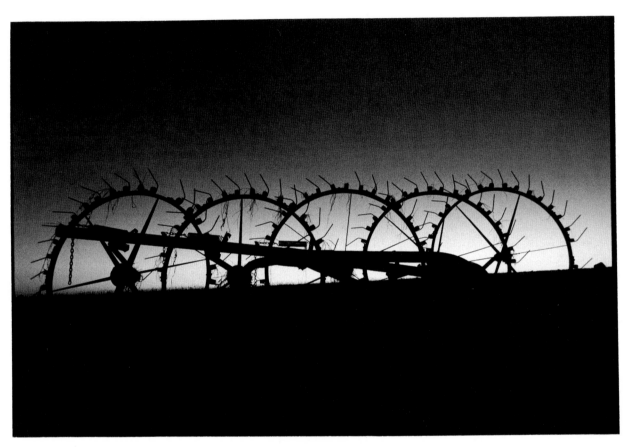

SUNRISE
Delaware County

Autumn

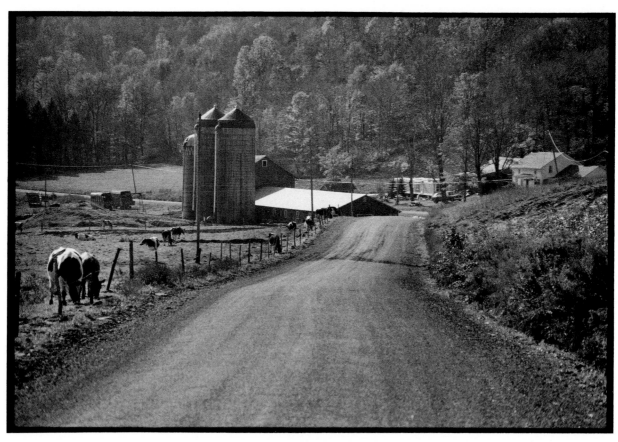

PASTURE AND BARN
Hamden

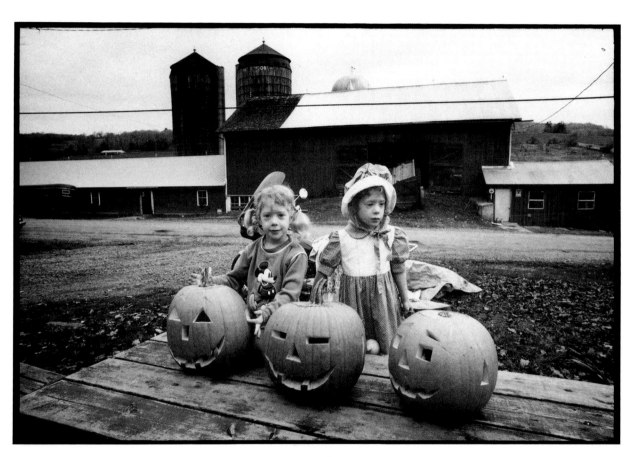

WAITING FOR HALLOWEEN
Hamden

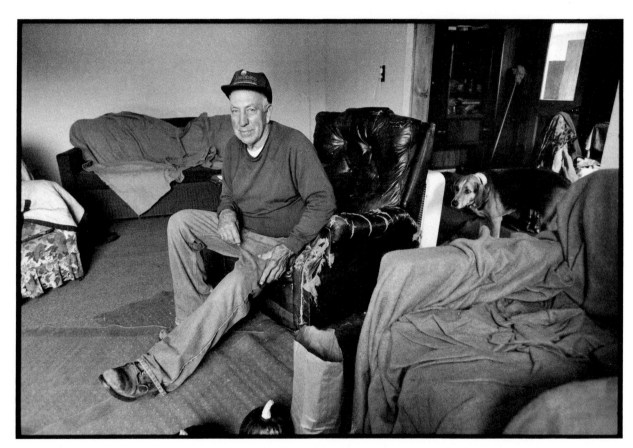

AT HOME
Treadwell

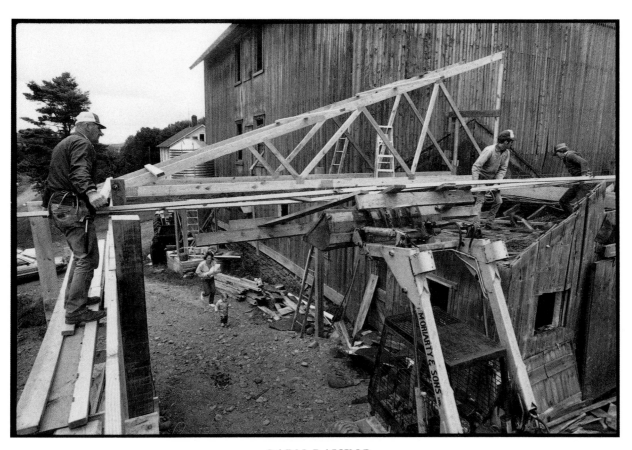

BARN RAISING
Delaware County

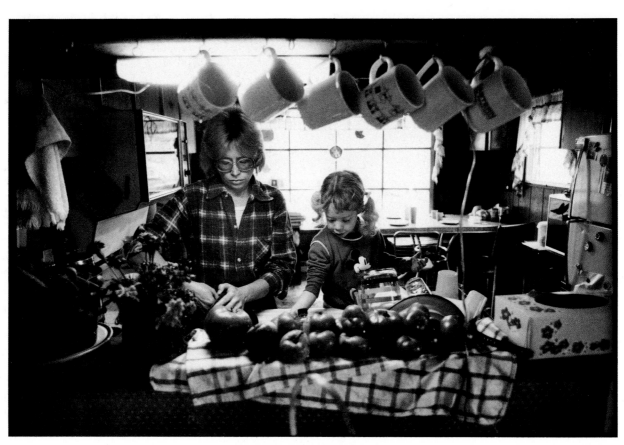

BREAKFAST CLEANUP
9 A.M., Hamden

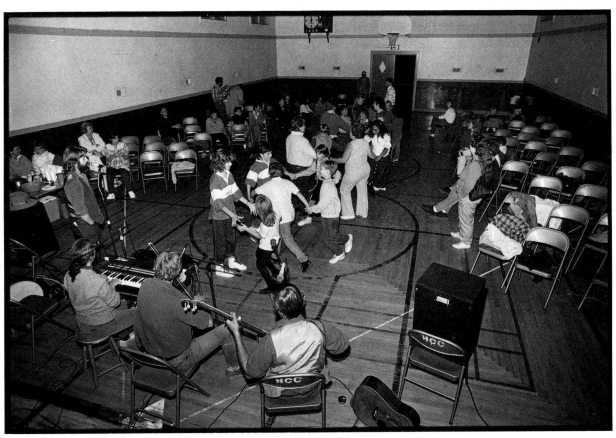

COUNTRY DANCE WITH "KLIPNOCKIE"
Hartwick

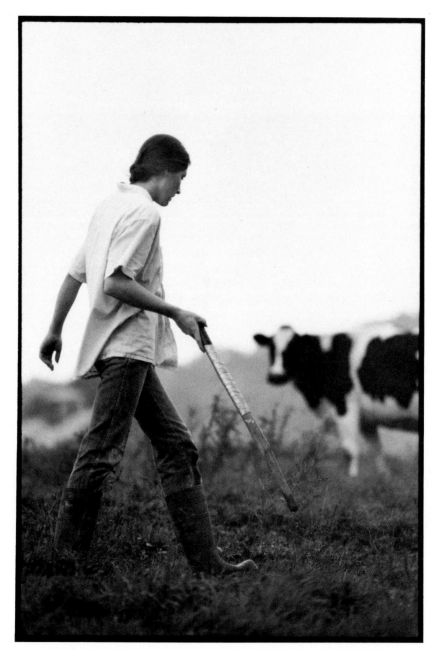

BRINGING THE COWS HOME ON THE OTSDAWA
Otsego County

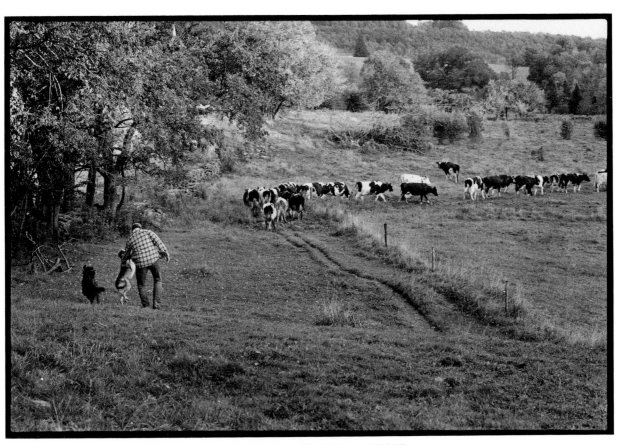

BRINGING THE COWS HOME
Delaware County

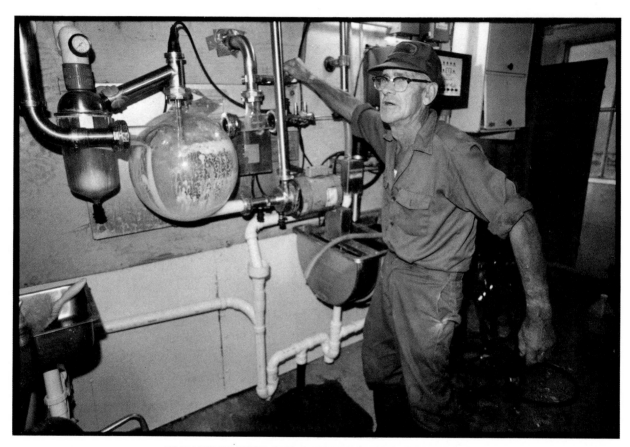

CLEANING THE MILK FILTRATION SYSTEM
Jefferson

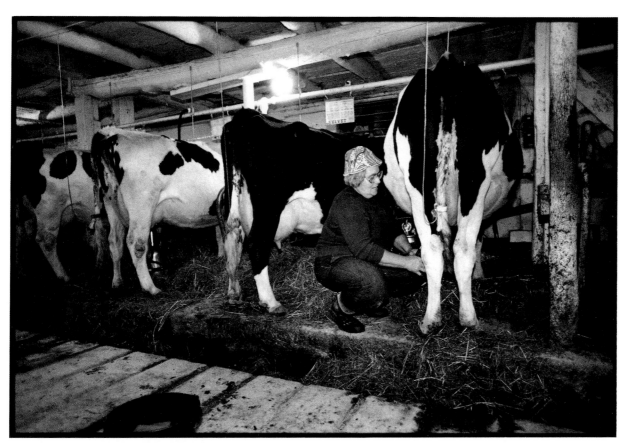

AFTERNOON MILKING
Meridale

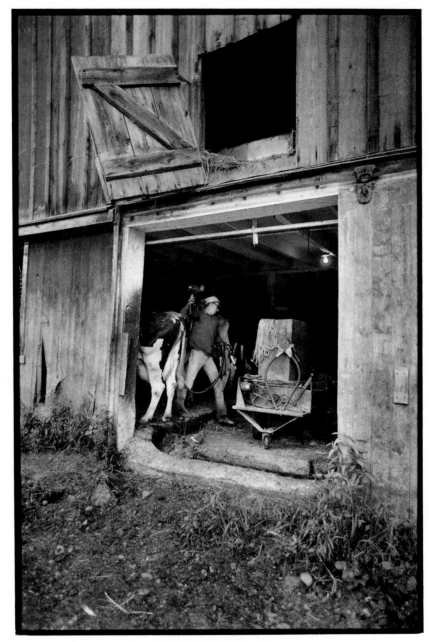

MORNING MILKING
Hamden

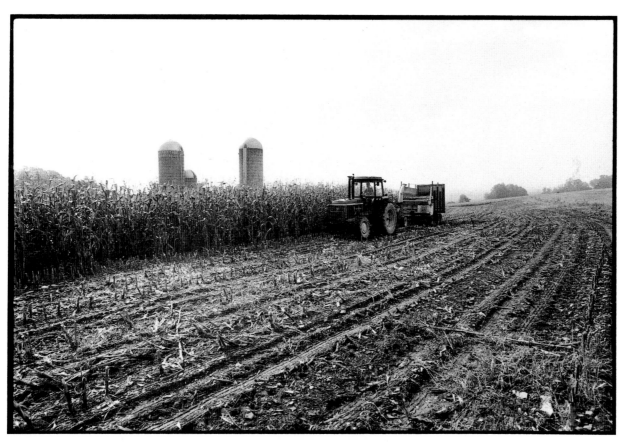

CHOPPING CORN
Otsego County

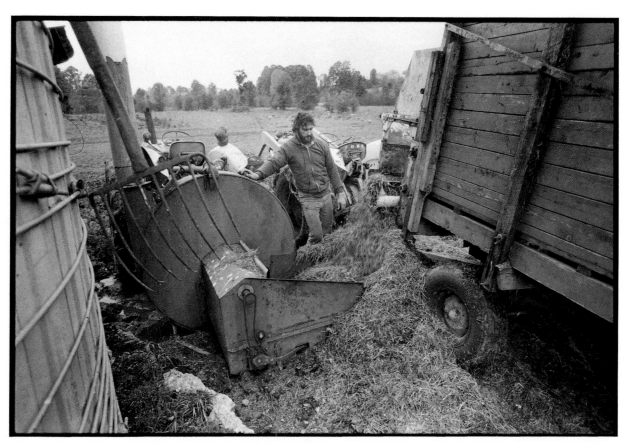

HAYING ON THE OSDAWA
Otsego County

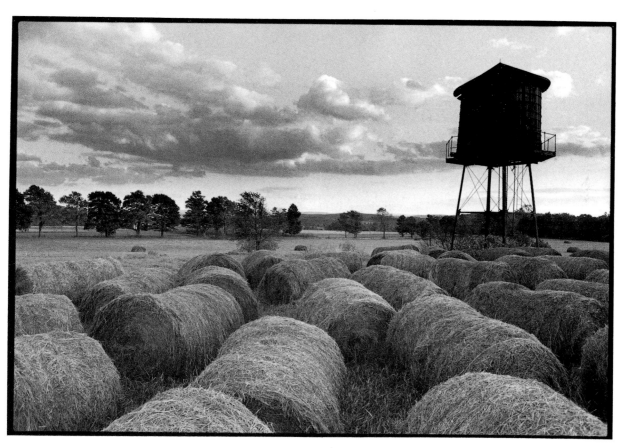

SUNSET ON THE CATSKILL TURNPIKE
Delaware County

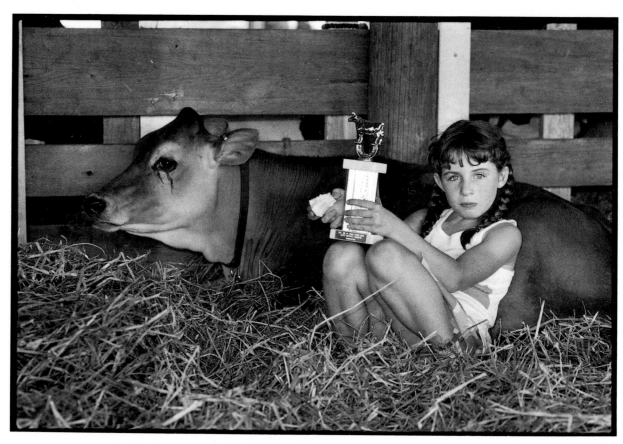

PRIZE JERSEY
Delaware County Fair, Walton

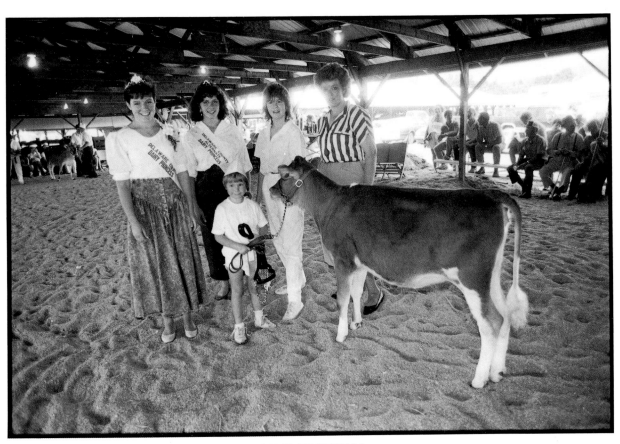

DAIRY PRINCESS
Delaware County Fair, Walton

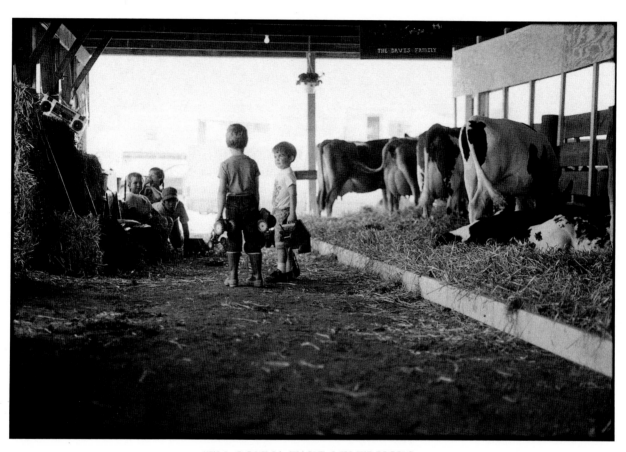

"I'M GONNA TAKE MY TRUCKS
AND GO PLAY IN MY OWN YARD."
Walton

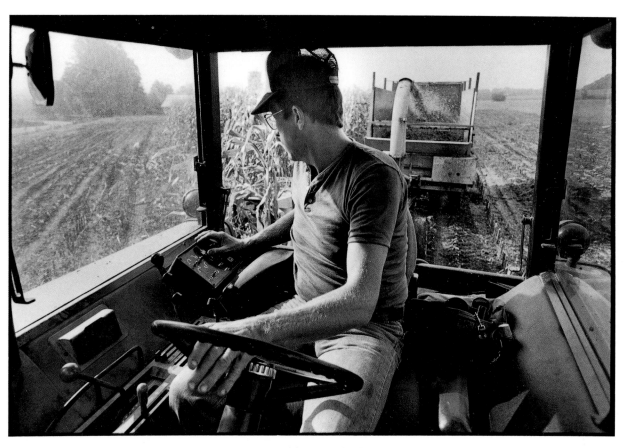

CHOPPING CORN IN THE BUTTERNUTS VALLEY
Ostego County

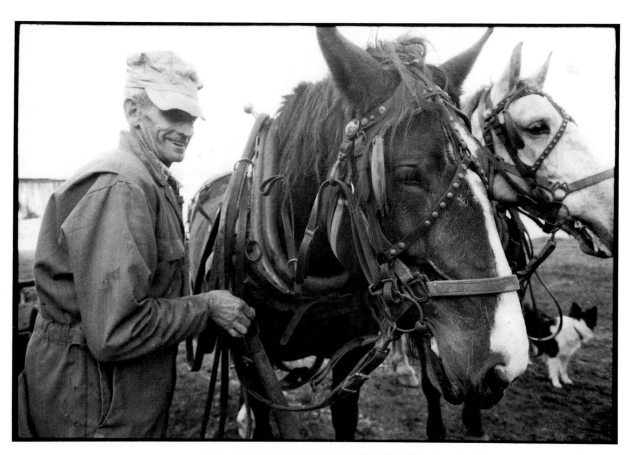

LES CRAWFORD AND BELGIANS
Otego

SEVENTY YEARS OF FARMING
Stamford